An illustrated coastal year

the seashore uncovered season by season

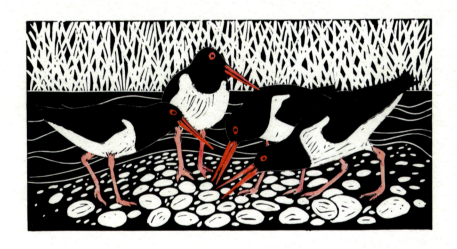

Celia Lewis

BLOOMSBURY WILDLIFE
LONDON · OXFORD · NEW YORK · NEW DELHI · SYDNEY

To ensure your own safety and to protect the seashore environment, download
and read the Seashore Code before any visit to the coast.

BLOOMSBURY WILDLIFE
Bloomsbury Publishing Plc
50 Bedford Square, London, WC1B 3DP, UK
29 Earlsfort Terrace, Dublin 2, Ireland

BLOOMSBURY, BLOOMSBURY WILDLIFE and the Diana logo are trademarks of Bloomsbury Publishing Plc

First published in the United Kingdom, 2015

Copyright © text and artworks by Celia Lewis, 2015

Celia Lewis has asserted her right under the Copyright, Designs and Patents Act, 1988,
to be identified as Author of this work.

All rights reserved. No part of this publication may be reproduced or transmitted in any form or by
any means, electronic or mechanical, including photocopying, recording, or any information storage
or retrieval system, without prior permission in writing from the publishers.

No responsibility for loss caused to any individual or organization acting on or refraining from action
as a result of the material in this publication can be accepted by Bloomsbury or the author.

A catalogue record for this book is available from the British Library.

Library of Congress Cataloguing-in-Publication data has been applied for.

ISBN: HB: 978-1-3994-0216-3

2 4 6 8 10 9 7 5 3 1

Designed by Julie Dando, Fluke Art
Printed and bound in India by Replika Press Pvt. Ltd.

To find out more about our authors and books visit www.bloomsbury.com and sign up for our newsletters.

Contents

Preface 5

Spring 6

Summer 50

Autumn 104

Winter 146

Useful websites 187

Acknowledgements 188

Index 189

For

Henrietta, Molly and Emma

With love and patience nothing is impossible Daisaku Ikeda

*The sea, once it casts its spell,
holds one in its net of wonder forever.*
　　　　　　Jacques Yves Cousteau

There is something delightful about walking along the strandline of a beach and looking to see what you can find. So many fascinating things wash up, sometimes from far afield, but look a little closer and you will discover that our 17,800 km of coast are home to flora and fauna that are found nowhere else.

It is said that no one in the British Isles lives further than about 110 km from the coast, and ours is a coast of contrasts with scenery that changes from estuaries, shingle beaches, saltmarshes and sand dunes, to rocky shores, rugged cliffs, machair and bustling industrial harbours.

Our varied and dynamic coastline offers some of the best places in the country to visit, so it is perhaps unsurprising that most of us have had a love affair with the seaside since our childhoods. We retain the potential to be surprised as adults when we return to seaside haunts of our youth and realise that there is not a rockpool, marsh or dune that does not provide the perfect conditions for some living thing to thrive.

The more you familiarise yourself with the diverse habitats that exist along our shores, the more you are likely to notice. This book is intended to enhance any visit to the coast at any time of year. It will, I hope, kindle the amateur naturalist in anyone, at any age. Whatever your reason for visiting our vast coastline, start a shell collection, make something from driftwood, hunt for edible plants or just look around and enjoy the incredible diversity of species that exist around our little archipelago.

Spring

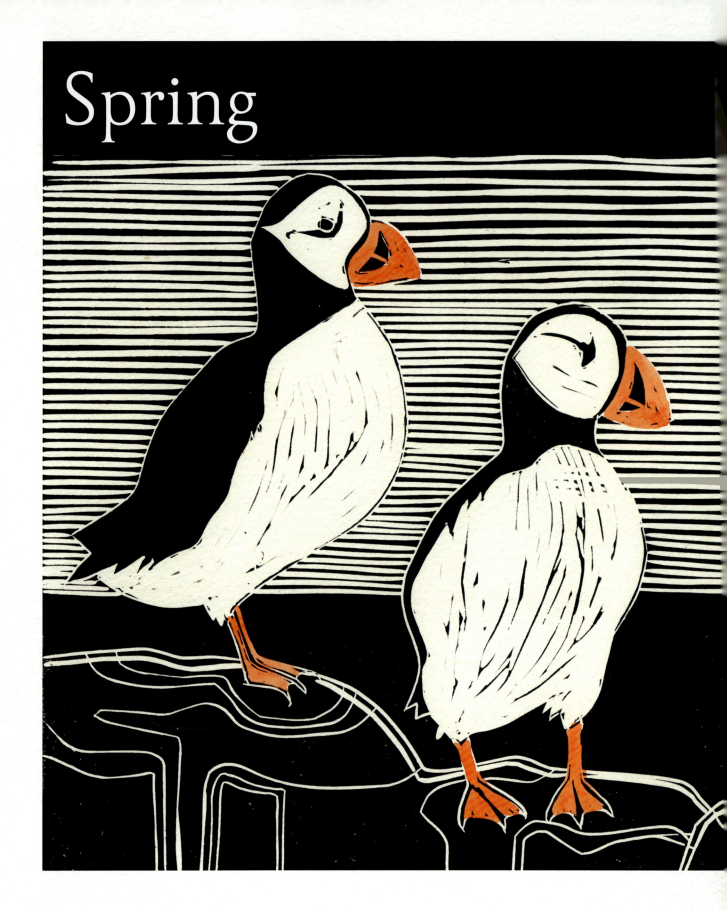

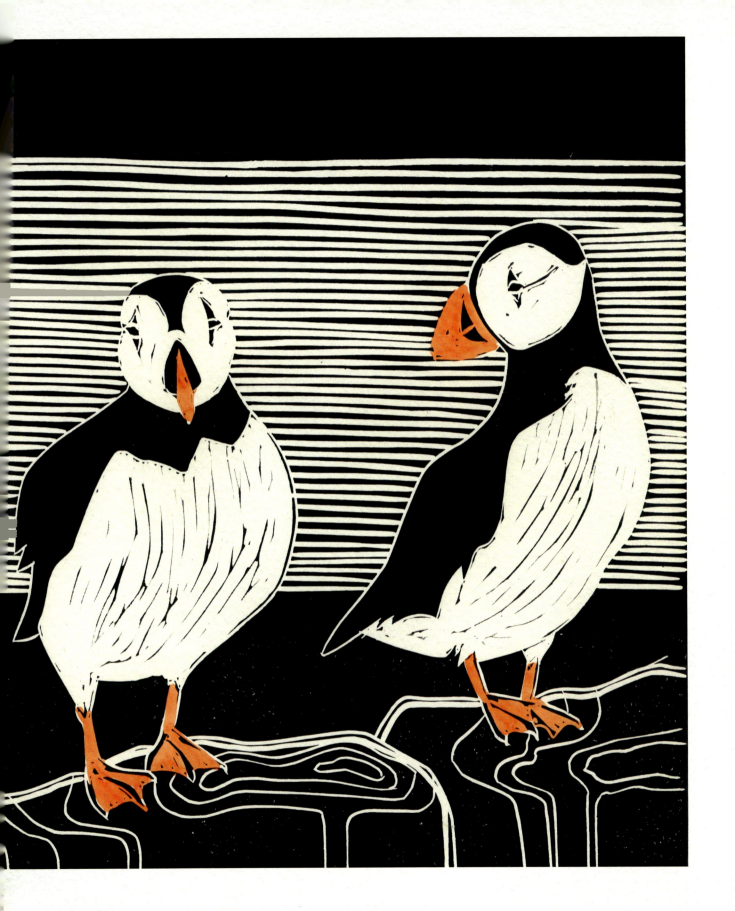

Is it a Redshank or a Greenshank?

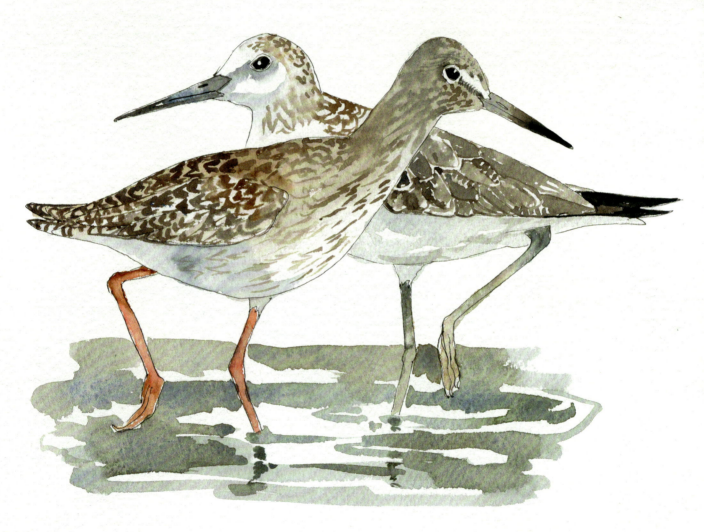

Redshank Greenshank

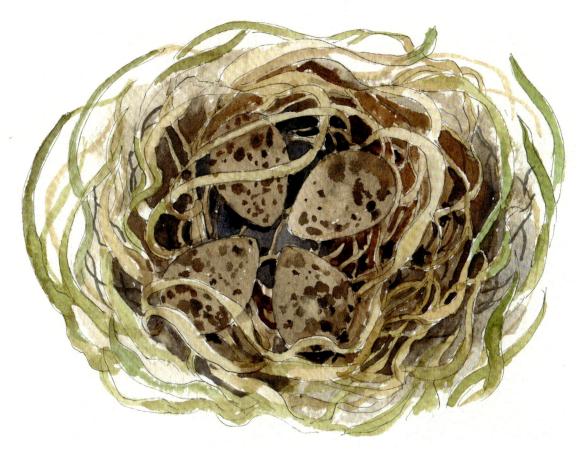

Redshank nest

The **Redshank** (*Tringa totanus*) is 28 cm long, with a wingspan of 62 cm. A grey-brown bird, it is darker above with a white rump and orange-red legs. It winters in estuaries and eats insects and earthworms, probing for them in the mud with its bill. It is noisy when disturbed and is sometimes called the sentinel of the marsh, as it is usually the first to fly away when alarmed. The female lays four eggs, and incubation takes 24 days.

Slightly larger than the Redshank, the **Greenshank** (*Tringa nebularia*) is 32 cm, with a wingspan of 69 cm. It has a grey-brown head, mantle and wings, a white rump and olive-green legs. It favours all water margins and estuaries, but is less common on sandy shores. The bird's diet consists of worms, snails and fish, and its voice is a musical, fluty *ru-ru*. The female lays 3–4 eggs, and incubation takes 25–27 days.

Spring

Rays and skates

The differences between rays and skates are rather confusing. According to the Shark Trust, as a general rule species with long snouts are known as skates, while those with shorter snouts are called rays. However, the Thornback Ray is actually a skate, as are the other two species illustrated here. The best way to distinguish rays and skates is by the way they produce their young. All true skates lay distinct egg cases, known as mermaid's purses (see opposite), whereas true rays give birth to live young. All rays can vary widely in their colouring.

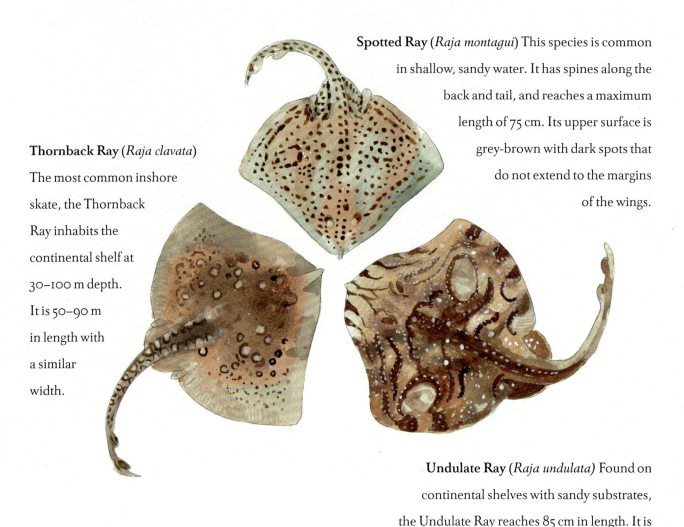

Spotted Ray (*Raja montagui*) This species is common in shallow, sandy water. It has spines along the back and tail, and reaches a maximum length of 75 cm. Its upper surface is grey-brown with dark spots that do not extend to the margins of the wings.

Thornback Ray (*Raja clavata*) The most common inshore skate, the Thornback Ray inhabits the continental shelf at 30–100 m depth. It is 50–90 m in length with a similar width.

Undulate Ray (*Raja undulata*) Found on continental shelves with sandy substrates, the Undulate Ray reaches 85 cm in length. It is grey-brown above, with dark lines bordered by white dots.

Mermaid's purses

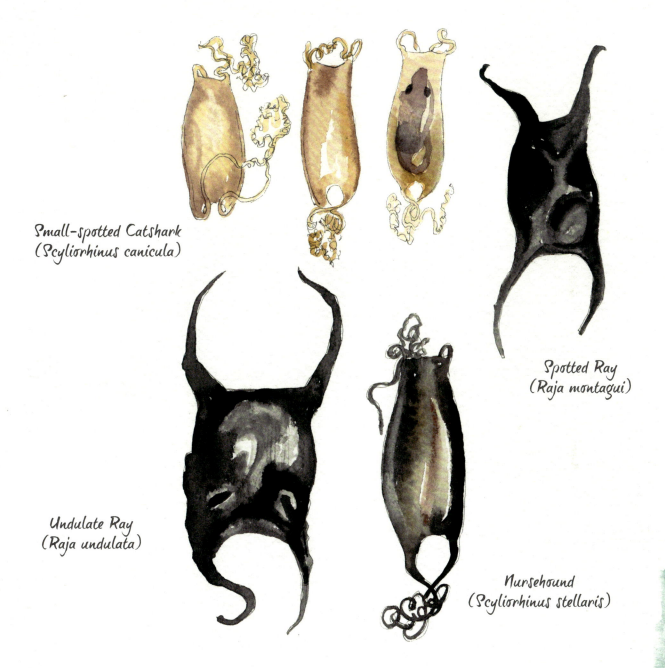

Small-spotted Catshark
(Scyliorhinus canicula)

Spotted Ray
(Raja montagui)

Undulate Ray
(Raja undulata)

Nursehound
(Scyliorhinus stellaris)

Spring

These are the egg cases of skates, rays and catsharks (see opposite). Each case contains one embryo, which takes several months to develop. Once the fish have hatched, the empty mermaid's purses, as they are known, float on to the shore.

Coastal-loving Cruciferae

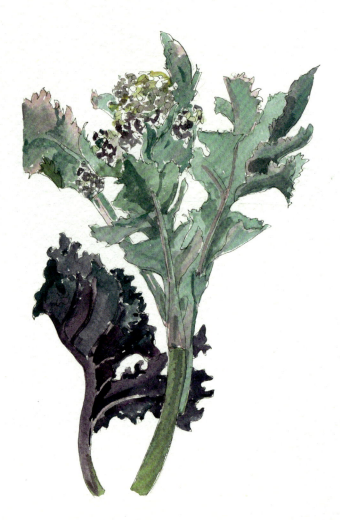

Sea Kale

- *Crambe maritima*
- Grows on pebble beaches.
- Edible and delicious.
- Steam for 5–10 minutes.
- Early spring for the shoots, May–June for the flowers (like broccoli) and until August for the leaves.

Sea Beet

- *Beta vulgaris maritima*
- Grows at the tops of beaches.
- Edible and similar to spinach.
- Steam for five minutes.
- Best when newly emerged and before flowering.

Jack in the Hedge or Garlic Mustard

- *Alliaria petiolata*
- Leaves may be boiled or eaten raw.
- Garlic scent if crushed.
- Flowers April to June.

Hoary Cress or Hoary Pepperwort

- *Cardaria draba*
- Grows on poor soil.
- Height to 80 cm.
- Flowers May to July.

Sea or Wild Cabbage

- *Brassica oleracea*
- Grows on cliffs.
- Edible.
- Steam young leaves for five minutes.

Lemon sole, cockles and samphire with garlic parsley dumplings and lemon sauce

I am grateful to Nathan Outlaw of Nathan Outlaw Restaurants Ltd for allowing me to use this recipe. Nathan says, 'Potato dumplings and a creamy lemon sauce add a touch of luxury to this fish dinner.'

Serves 4

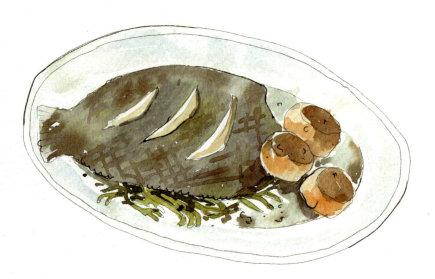

4 small lemon sole fillets, trimmed and washed

500 g live cockles

110 ml water

300 g samphire

200 g broad beans, blanched, refreshed and podded

1 tbsp flatleaf parsley, chopped

For the dumplings

2 tbsp olive oil

salt and pepper

300 g baked potatoes, cooked and cooled, flesh pushed through a ricer or sieve

1 garlic bulb, roasted whole, soft cloves peeled and pushed through a sieve

1½ tbsp grated Parmesan cheese

1 egg yolk

75 g Italian 00 flour or strong white flour

2 tsp lemon oil

3 tbsp flatleaf parsley, chopped

For the lemon sauce

 1 egg yolk

 1 lemon, juice and zest

 200 ml light olive oil

 50 ml double cream

 110 ml fish stock

Preheat the grill to medium-hot.

Put the fish on a baking tray and season. Place under the grill and cook for approximately 10 minutes, or until the flesh comes away from the bone.

Meanwhile, place a pan with a lid on the cooker and heat. When the pan is hot add the cockles. Add the water and immediately cover with the lid. Steam the cockles for a minute, then drain. Discard any cockles that have not opened. When cool enough to handle, pick the cockles from their shells.

For the dumplings, bring a large pan of water to a simmer. Add 1 tsp of the olive oil and a pinch of salt.

Place the potatoes, garlic, Parmesan cheese and egg yolk in a bowl, and fold together (do not overwork them). Fold in the flour, lemon oil and parsley. Season and place on a clean work surface.

Divide the dough, fashion into small balls and blanch in the simmering water until the dumplings rise to the surface. Plunge into ice-cold water, and when cold transfer to a tea towel to dry.

Heat a non-stick pan until hot. Add the remaining oil and the dumplings and fry until they are golden-brown. Drain on kitchen paper.

For the lemon sauce, place the egg yolk, lemon juice and zest in a bowl, and whisk together. Slowly add the oil in a thin stream, whisking all the time, to make a mayonnaise.

Whisk the cream into the mayonnaise and add enough fish stock to thin the mayonnaise to a sauce consistency (you will not need all the stock). Place the sauce in a pan and gently warm through.

Bring a pan of salted water to the boil. Just before serving, plunge the samphire into the water and cook for two minutes.

To serve, add the cooked cockles, samphire, broad beans and parsley to the sauce, and bring to just below a simmer. Place the cooked fish on serving plates and pile the dumplings alongside. Use a slotted spoon to remove the cockles, samphire and broad beans from the sauce and serve alongside the fish.

Large marine molluscs

Superficially quite unlike other molluscs, octopuses, squid and cuttlefish (and Nautiluses, found only in the Indo-Pacific) are all Cephalopods, an ancient class of animals that can change colour faster than a chameleon, alter body shape and texture, and use a cloud of ink as a smokescreen or decoy if threatened.

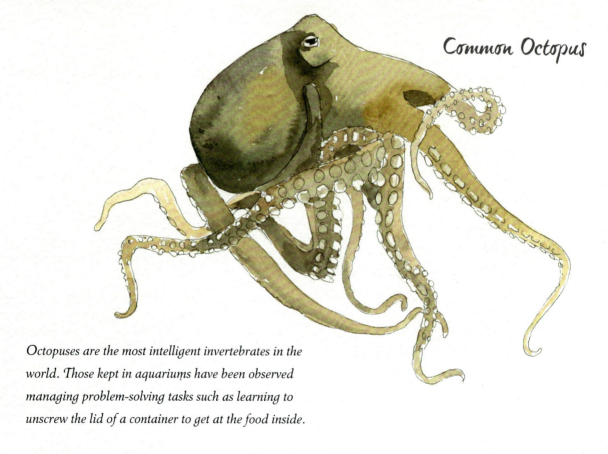

Common Octopus

Octopuses are the most intelligent invertebrates in the world. Those kept in aquariums have been observed managing problem-solving tasks such as learning to unscrew the lid of a container to get at the food inside.

Common Octopus (*Octopus vulgaris*) This octopus has a mantle length of 20–30 cm and an arm span of around a metre. It is found mainly to the south and west of the UK, favouring rocky areas at a depth of 50 m or more. The species has eight arms each with two rows of suckers; these are used for tasting whatever the sucker touches. The skin colour of the octopus changes to adapt to its surroundings. Octopuses can 'walk', swim slowly or use 'jet-propulsion' to shoot forwards by expelling water from their bodies. They hunt for crustaceans and shellfish, and pull them apart with their powerful arms. They also secrete a form of poison to break down the muscles of their prey.

Common Cuttlefish (*Sepia officinalis*) Up to 50 cm in length and 3.5 kg in weight, the Common Cuttlefish is found all around the UK, but is most common in the south. It has a rather flat body with a broad head and eyes on either side that have W-shaped pupils, and eight arms with multiple suckers. The longest tentacles are kept tucked away in pouches by the side of the head when they are not in use. The animal is capable of changing colour to blend with its surroundings, and lives in water to a depth of 250 m.

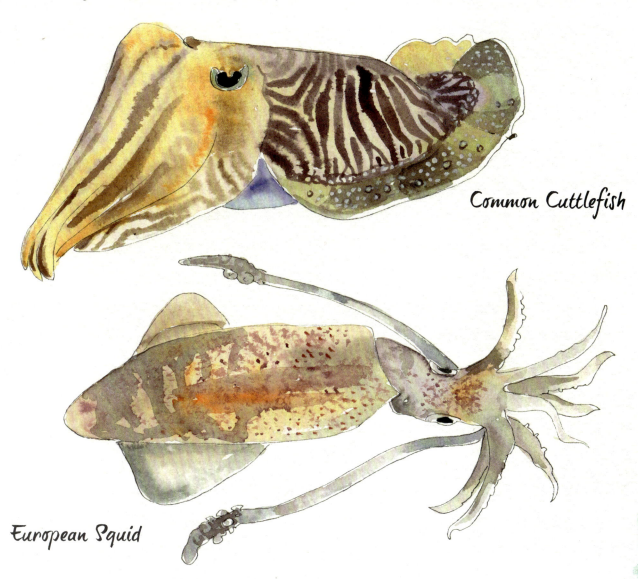

Common Cuttlefish

European Squid

European or Common Squid (*Loligo vulgaris*) This species has a mantle length of up to 50 cm. It is found in all European waters. The species has eight arms surrounding the beak, with two longer tentacles with suckers at the tip used to catch prey. It lives between the water's surface and a few hundred metres depth in summer, but prefers depths of 500–1,000 m during winter.

Spring

Bony fish found in inshore waters

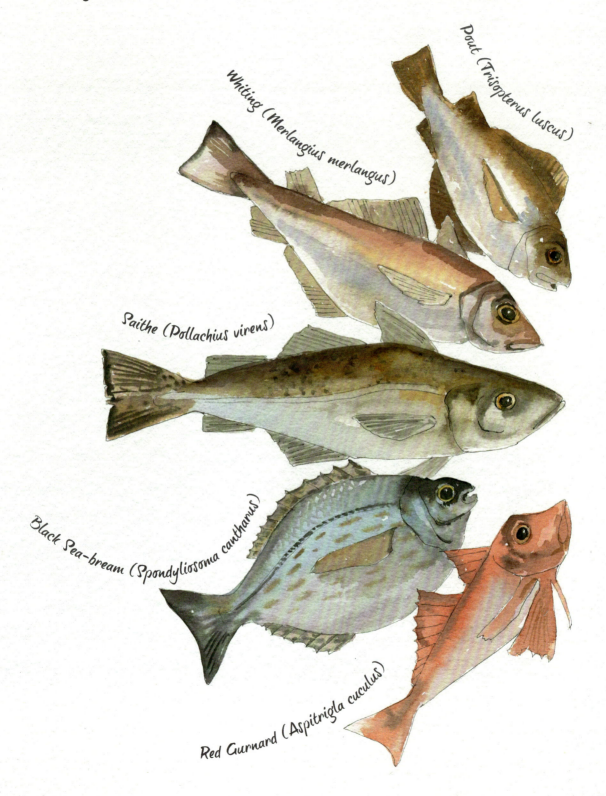

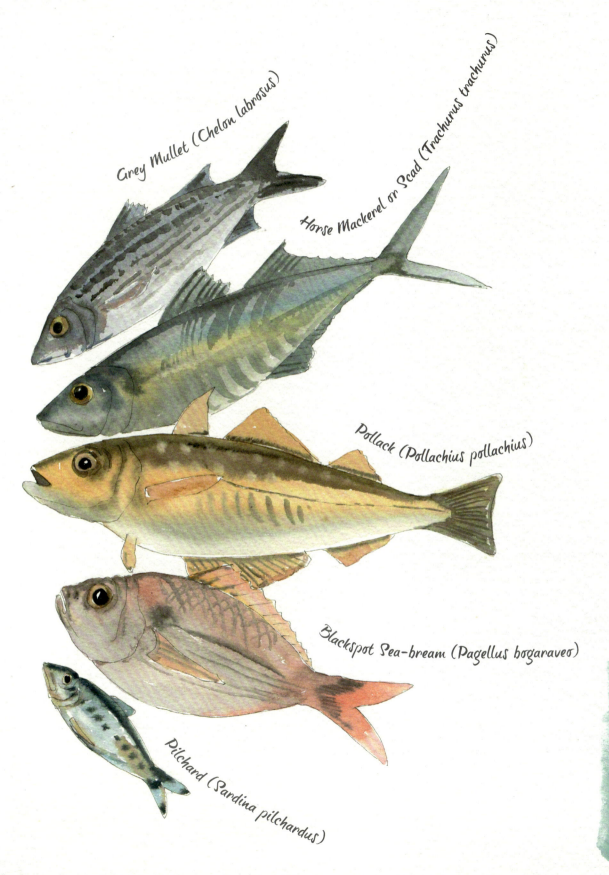

How to make shell spoons

This is very simple but fun to do. You can use the spoons for salt or other lightweight condiments. They will not be very robust – just pretty.

YOU WILL NEED:

 shells

 paperclips and/or bendy wire

 drill with a very small bit

 small pliers

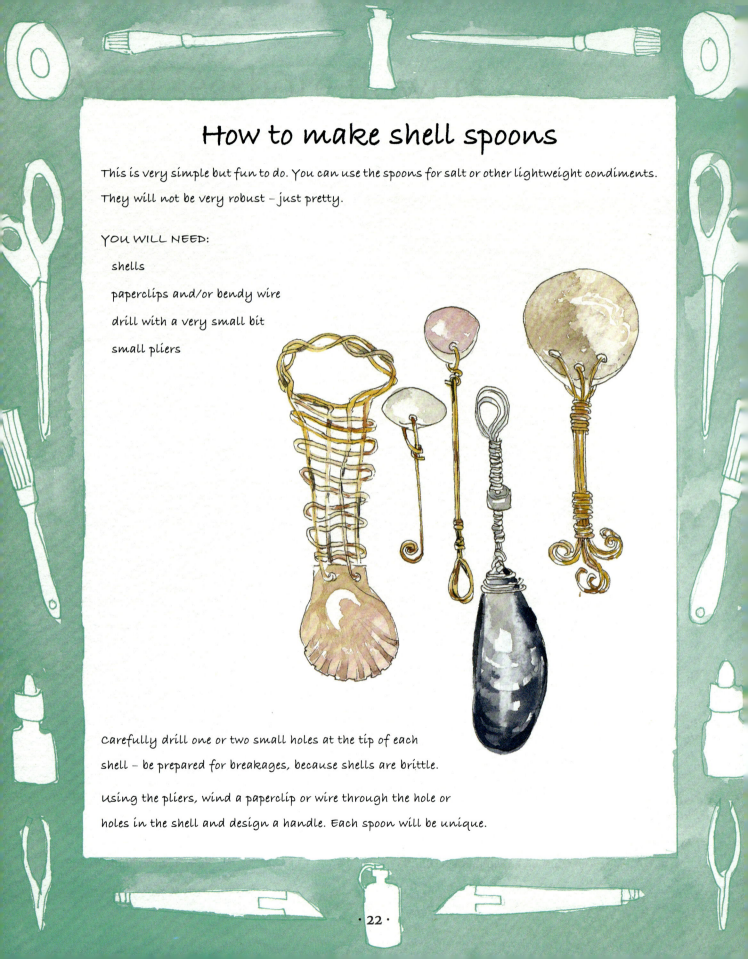

Carefully drill one or two small holes at the tip of each shell – be prepared for breakages, because shells are brittle.

Using the pliers, wind a paperclip or wire through the hole or holes in the shell and design a handle. Each spoon will be unique.

Tides and the moon

If you are visiting the coast you need to know what the tide is doing, particularly if you intend to do things like rockpooling or hunting for mussels. Even if you just want to build a sandcastle, if it turns out to be high tide there may be no sand showing. Bear in mind it is always safest to go swimming or boating when the tide is coming in.

What you need is a local tide table. You will find that there are two high and two low tides every day, each tide averaging just over six hours, so that high and low tides will be at slightly different times each day (50 minutes later day by day).

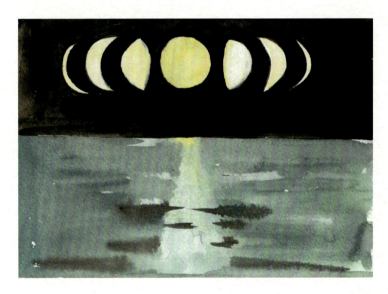

The gravitational forces of the moon and sun dictate the tides, the strongest pull being when the sun, Earth and moon are in line at the full and new moons. This causes 'spring' tides that are extra high as well as extra low. At the halfway stage, when the moon is waxing or waning, the opposite occurs.

Always keep an eye out on the tides in coastal areas (tide tables are available on the Internet). The tides around Britain's coast are strong, and can advance very rapidly. A seemingly innocent depression can quickly turn into an impassable barrier in some areas where there is a marked tidal range. In some places an incoming tide can come in faster than walking speed. Exploring a seashore is best done on a falling tide, so make a note of the timing of low tide and check your return route before embarking on your explorations.

Spring

Red seaweeds

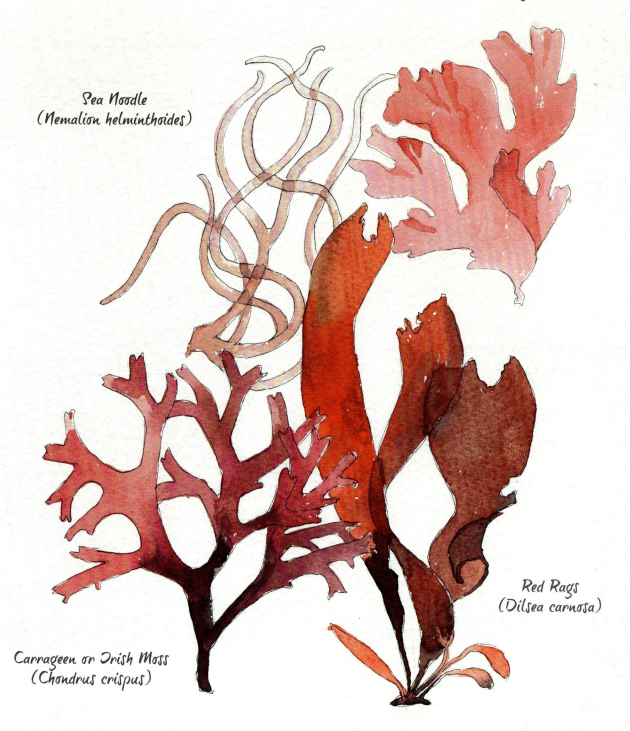

Fan Weed
(Callophyllis laciniata)

Sea Noodle
(Nemalion helminthoides)

Red Rags
(Dilsea carnosa)

Carrageen or Irish Moss
(Chondrus crispus)

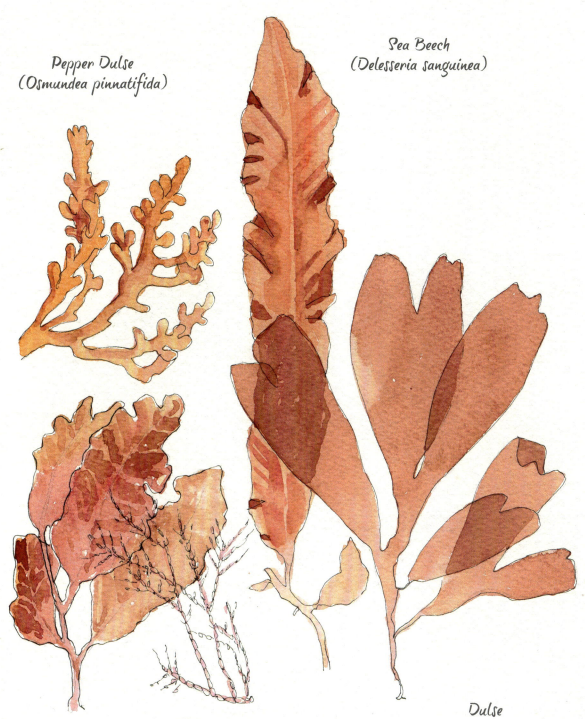

Oystercatcher

The **Oystercatcher** (*Haematopus ostralegus*) is an iconic seashore bird that is easy to identify not only because of its smart black-and-white markings, but also by its loud, shrill calls. The reddish-orange bill and pink legs are also a giveaway.

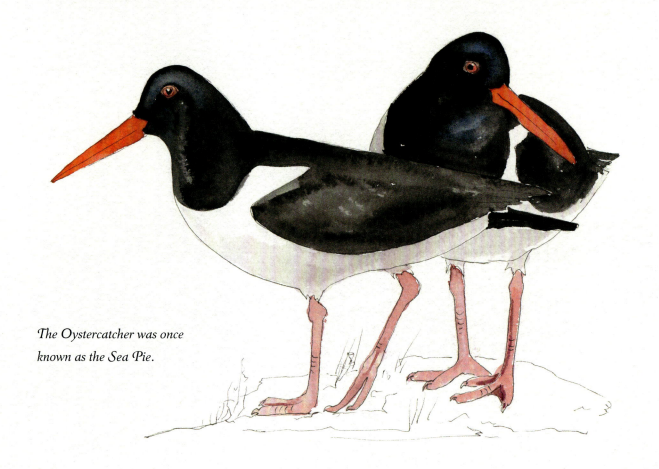

The Oystercatcher was once known as the Sea Pie.

A wading bird, the Oystercatcher doesn't actually eat oysters but prefers cockles and mussels, using its strong bill to open them by hammering through the shell or managing to prise the two shells apart. Apart from molluscs, they also feed on crustaceans, worms and insects.

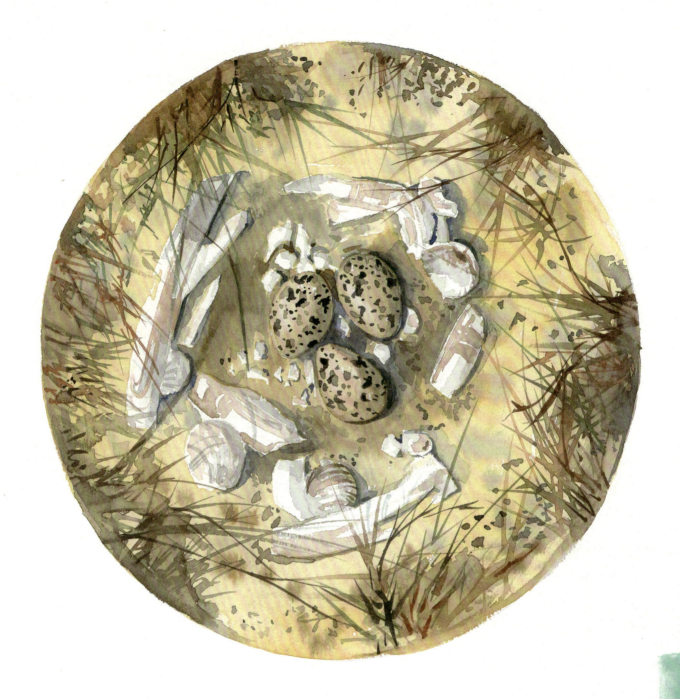

The birds nest in shingly sandy places usually near the shore, but also occasionally inland on moorland and even arable fields, and are found all around the coast of the UK. Usually 2 or 3 eggs are laid, incubated by both parents in turn, which take between 24 and 27 days to hatch. The chicks are precocial or ready to run immediately after birth. They are fed by their parents, usually on a diet of earthworms, and can not feed themselves at first which often results in only two chicks surviving.

Spring

Land and sea spaghetti with anchovy, white wine and chilli

This is a recipe developed by Ellen Parr for the seaweed supplier Atlantic Kitchen. It is a very unusual pasta dish. The sea spaghetti is the species Thongweed or Sea Thong (*Himanthalia elongata*), and is available dried.

Serves 4

 100 g sea spaghetti

 200 g linguine

 4 tbsp extra virgin olive oil

 3 garlic cloves (sliced thinly)

 8 anchovy fillets in olive oil

 pinch of chilli flakes

 100 ml white wine

 handful of parsley, chopped

Cook the sea spaghetti and linguine according to the packet instructions. (Cook them together if you are short on pots and time, but otherwise it is best to cook them separately.)

Meanwhile heat a small saucepan, and when hot add the olive oil, then turn down the heat.

Add the garlic, and fry it but do not let it colour. Add the anchovy fillets and stir until they have melted into the oil.

Add half the chilli flakes, then turn up the heat again and when hot, throw in the white wine. Shake the pan so that the liquid emulsifies.

Allow the liquid to reduce by about half, then add some of the linguine water if you think more liquid is needed.

Drain the sea spaghetti and rinse under warm water, then add to the saucepan.

Drain the linguine. Reserve some of the pasta water, and add the linguine to the saucepan. Stir through the parsley, adding pasta water if you want to loosen the mixture.

Scatter the remaining chilli flakes on top, and serve.

Sea salt

Salt is made up of two minerals, sodium and chlorine. It is used in cooking to add flavour to food, and also as a preservative. There are three types of salt: sea salt, rock salt and table salt, all of which contain around 100 per cent sodium chloride. Because of this, too much of any of them will have a negative effect on your health.

Rock salt is mined from the earth and is therefore already solid. Table salt is refined to remove impurities, but this means that minerals such as magnesium and potassium are also removed. Sea salt contains more minerals and is thought to be better for your health – in moderation.

In order to produce sea salt you basically need to evaporate seawater, although the process is not quite as simple as it would seem. Once upon a time seawater would have been evaporated in clay pans over open gorse fires, but technology has moved on. Today fresh seawater is pumped into a harvesting plant and goes through a three-stage filtration process and UV light treatment to rid it of silt, sand and micro-organisms. The seawater then has a proportion of its salt minerals removed and is concentrated into a super-saturated brine. The brine is poured into vats and heated. Over two days delicate salt crystals form on the surface; these are hand harvested throughout the day and night to give the desired texture. The water is returned to the sea.

Spring

Starfish

Starfish, or sea stars, are members of a group of invertebrates known as echinoderms. Starfish all possess radial symmetry, typically with a central disc and five arms, and with an upper surface that may be smooth, granular or spiny. Starfish have a central mouth and may either graze or predate. The word echinoderm actually means 'spiny skin' and they all have an outer skeleton made up of calcified plates.

Spiny Starfish (*Marthasterias glacialis*) Up to 70 cm. Large, with five long, grey-green arms, and covered all over the upper surface with large spines.

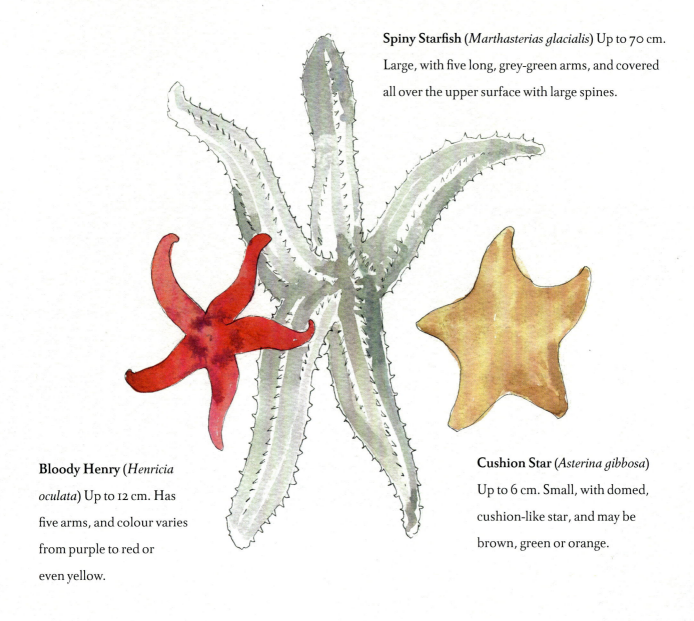

Bloody Henry (*Henricia oculata*) Up to 12 cm. Has five arms, and colour varies from purple to red or even yellow.

Cushion Star (*Asterina gibbosa*) Up to 6 cm. Small, with domed, cushion-like star, and may be brown, green or orange.

Common Starfish (*Asterias rubens*) Up to 30 cm. Usually has five arms, and is reddish-brown with white spines.

Common Sun Star (*Crossaster papposus***)** Up to 35 cm. Large central disc with 11–14 short arms. Reddish on top with concentric bands of white, pink, yellow or dark red, and white on underside.

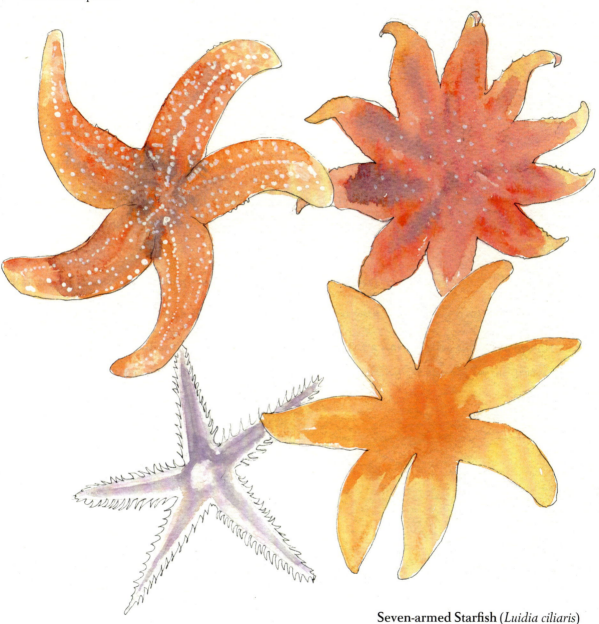

Sand Star (*Astropecten irregularis*) Up to 20 cm. Rather flat with five stiff and spiny arms, and pinkish-orange with arms often tipped violet.

Seven-armed Starfish (*Luidia ciliaris*) Up to 50 cm. Has seven arms but frequently loses one or more of them, and is orange-brown in colour.

Spring

Alexanders

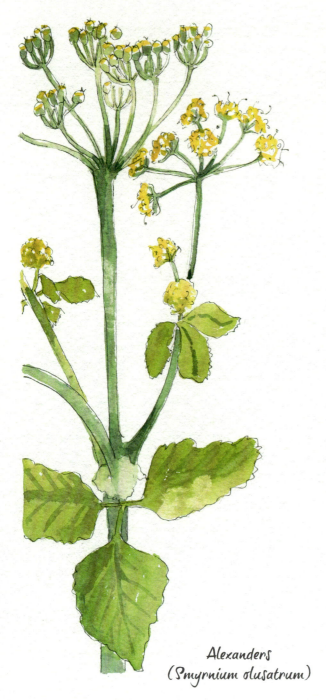

Alexanders
(*Smyrnium olusatrum*)

I am grateful to Emma Gunn of the Eden Project for allowing me to use the following information about Alexanders from her book *Never Mind the Burdocks*.

Also known as Alisanders or Horse Parsley, Alexanders (*Smyrnium olusatrum*) grows on cliff tops and in seaside hedgerows. In the spring it produces yellow-green flowers, and in the autumn black seeds. It grows to a height of 50–120 cm and has a hollow, grooved stem.

Here are just a few ways to prepare this wild food.

Fresh stems, flowers and leaves To enjoy the stems as a fresh vegetable – similar to asparagus – try peeling them and boiling them for 5–10 minutes, or until tender. Cook unripe flowerheads in the same way, or eat them raw. Large leaves can be blanched briefly, while young ones can be eaten raw.

Candied stems You can candy stems like angelica, to use for decorating cakes or to eat as a sweet snack. Peel the stems and boil them in a pan of water and sugar (one cup of each) for 10 minutes. Then drain them and lay them on non-stick parchment that has been covered with caster sugar; sprinkle more caster sugar on top. When they are dry, shake off the excess sugar and store the candied stems in a sealed, dry container.

Tempura flowerheads Both ripe and unripe flowerheads can be dipped in tempura batter and deep fried until golden, Japanese style.

Spicy seeds The hard black seeds appear late in the year and can be used as a spice, much like black pepper.

Roasted roots Scrub, peel and slice the roots – much like you would prepare parsnips. Toss them in sunflower oil, season, then roast at 180° C for 20 minutes or so, until tender. (Bear in mind that you must not dig up plants without a landowner's permission.)

Spring

· 33 ·

Emma's life-enhancing salt and pepper squid with guacamole dip

This is my daughter Emma's recipe. She says, 'This is quick and easy to prepare and not only does it have life-enhancing properties, but if you close your eyes you could imagine yourself transported to a Mediterranean island! Only ever buy squid from sustainable sources.' If you prefer, you can make a garlic mayonnaise as an alternative to the guacamole dip, by combining two crushed garlic cloves with some mayonnaise.

Serves 4

For the squid

 400 g large squid, cleaned

 2–3 tbsp extra-virgin olive oil (the best you can get)

 2 tsp sea salt

 1 tsp freshly ground black pepper

 1 tsp paprika, if you want to add a bit of a kick

 few sprigs of coriander, chopped

For the guacamole

 2 very ripe avocados

 1–2 fresh red chillies, finely chopped

 few sprigs of coriander, finely chopped

 ½ red onion, finely chopped

 2 garlic cloves, finely chopped

 1 tomato, finely chopped

 juice of 2 limes

 salt and pepper, to taste

You can cook the squid on either a griddle pan or a barbecue, so heat this up.

Meanwhile use kitchen scissors to cut open the body of the squid, then wash it well and pat it dry. Cut into roughly 3-cm strips, then with a sharp knife score criss-crosses across the strips and brush with olive oil.

To make the guacamole combine all the ingredients in a bowl and stir, crushing the large chunks of avocado with a fork as you go. Season with salt and pepper.

Mix together the sea salt, black pepper and paprika, if using, and sprinkle on both sides of the squid.

Make sure the griddle pan is very hot. Cook the squid pieces for about 1 minute on each side, until they start to curl.

Place on a plate and garnish with some coriander. Serve with the guacamole to dip the strips into, and a fresh green salad on the side.

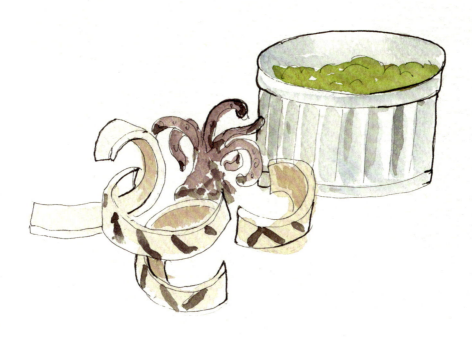

Common Guillemot

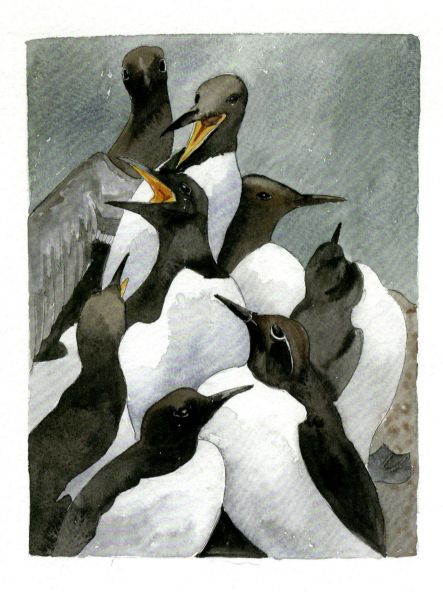

Common Guillemots (*Uria aalge*) spend most of their lives at sea, coming ashore to breed on rocky cliffs. They are also known as Murres because of the strange murmuring noise they make. Members of the auk family, they can manoeuvre very well underwater, using their wings to propel themselves and appearing to 'fly'. Males and females are indistinguishable from each other, but some individuals, known as 'bridled' birds, have a white ring around the eye that extends backwards.

Guillemots nest in colonies and each pair lays a single egg that takes 28–34 days to incubate, both parents taking their turn in this duty. If the first egg is lost the female may lay a second one, smaller than the first, but the chick has the ability to grow faster than a chick hatching from a first egg. The adults nest extremely close to each other, sometimes with only a beak length around them.

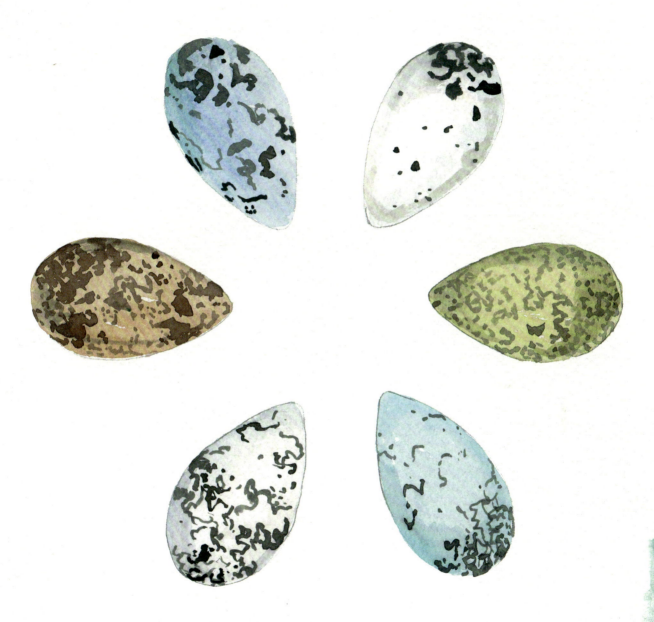

This clever bird has developed its eggs in such a way that not only are they shaped so as not to roll off the ledges they are laid on, but they also have a coating on the shells that makes them self-cleaning. The single eggs vary in colour and design, and this characteristic is thought to help the parents recognise their own eggs, with each one being unique.

Spring

April seashore flowers

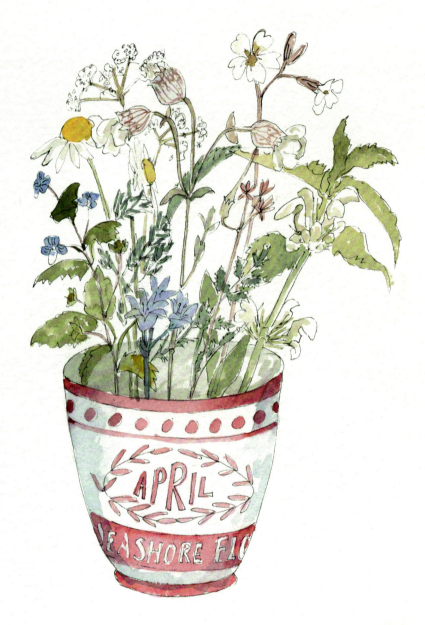

Left to right:

Germander Speedwell (*Veronica chamaedrys*)

Ox-eye Daisy (*Leucanthemum vulgare*)

Bur Chervil (*Anthriscus caucalis*)

Spring Squill (*Scilla verna*)

Bladder Campion (*Silene vulgaris*)

Common Stork's-bill (*Erodium cicutarium*)

White Campion (*Silene latifolia*)

White Dead-nettle (*Lamium album*)

How to make a driftwood table lamp

YOU WILL NEED:

 gnarled driftwood in different shapes

 glue gun

 5-cm square of plywood with the bulb fitting attached

 cable

 lampshade

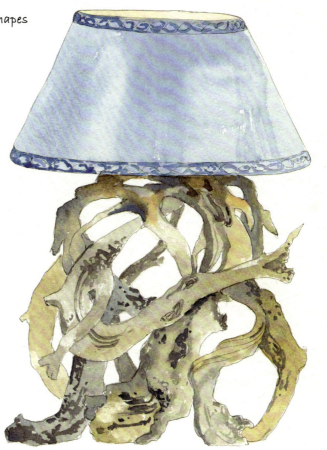

Build your lamp by gluing pieces of driftwood together. An extra pair of hands would be useful here as you need to hold the pieces in place while the glue sets, making sure you have a firm base. Leave room for a small platform at the top to which you can attach the bulb fitting. The brass bulb fitting will come supplied with three screws and a screw ring that will keep the lampshade in place. If it doesn't already have a cable one will have to be attached, which can be hidden behind one of the pieces of wood.

Elderflower and carrageen panna cotta

You can use either dried or fresh carrageen for this unusual version of a panna cotta from Prannie Rhatigan's esteemed Irish Seaweed Kitchen. If you use fresh carrageen the colour will be slightly darker than if you use the dried version.

Serves 6–8

 25 g dried carrageen or 150 g fresh

 200 ml double cream

 50 g sugar

 250 ml milk

 12 elderflower heads

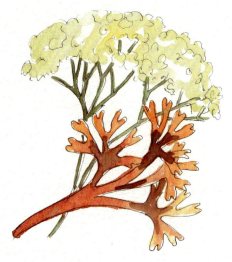

If using dried carrageen, soak it in cold water for 20 minutes.

Put the cream and sugar in a pan and gradually bring to a boil, stirring occasionally. Remove from the heat.

In a separate pan bring the milk, carrageen and elderflower heads to a boil, then simmer carefully for 10 minutes until the milk begins to thicken.

Sieve the milk and carrageen mixture into the cream and pour into small pudding moulds. Allow to cool, then leave to set in a refrigerator before turning out.

May flowers that grow in shingle

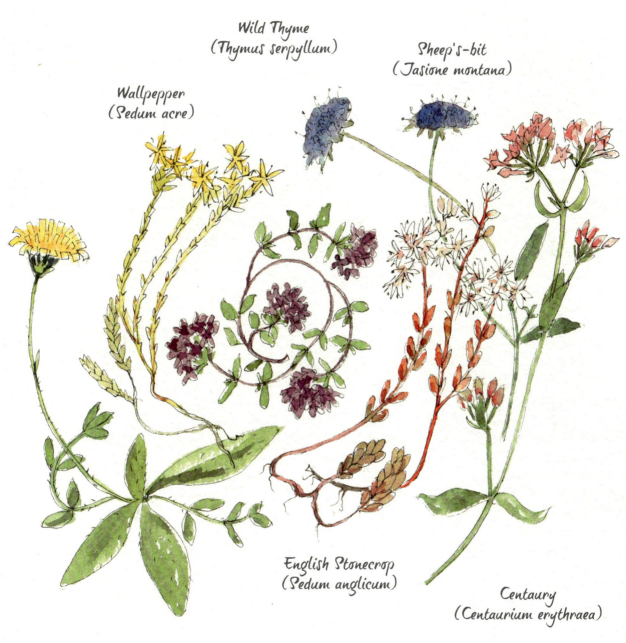

Wild Thyme
(*Thymus serpyllum*)

Sheep's-bit
(*Jasione montana*)

Wallpepper
(*Sedum acre*)

English Stonecrop
(*Sedum anglicum*)

Centaury
(*Centaurium erythraea*)

Mouse-ear Hawkweed
(*Pilosella officinarum*)

Spring

Atlantic Herring

Herring is the old Norse word for 'army', a suitable name as these fish move around together in huge numbers. Atlantic Herring (*Clupea harengus*) are also known as sild when processed as sardines. They filter feed on plankton and very small creatures, including sprats and fry of other fish. In turn they are an important source of food for a huge number of other animals, such as gannets, dolphins, seals and all other predatory fish. Herring have been of importance to humans since around 3000 BC and can be preserved or cooked in many ways:

- Rollmops are pickled herring fillets.
- Kippers are herring that are split in half, gutted, salted and cold smoked.
- Bloaters are similar to kippers but have not been gutted.
- Soused herring is cooked in a marinade of vinegar or wine.
- Buckling is a hot-smoked whole herring, gutted but with the roe remaining.

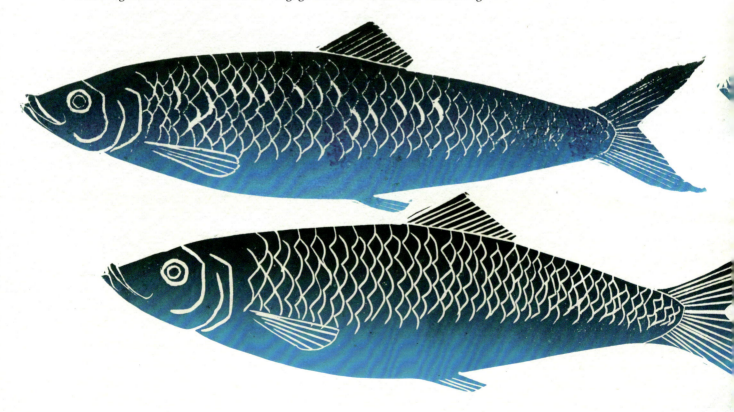

Herring breed the whole year round, producing millions of eggs that drop to the seabed. These hatch after 10 days if the water is warm, but take up to a month to do so if the sea is cold. The fry have small yolk sacs attached to them. These keep them going until they reach about 10–15 cm in length; after this they must feed themselves.

Drawing a red herring across the path

Trying to divert attention from the main question by some side issue. A red herring (that is, one dried, smoked and salted) drawn across a fox's path destroys the scent and sets the dogs at fault.
Brewer's Dictionary of Phrase and Fable

Spring

Common Tern

Although rather awkward on land, in the air the elegant, fast-flying Common Tern (*Sterna hirundo*) makes breathtaking dives from a height onto its prey in the water. The bird is a summer visitor that breeds on any sandy or shingle shore, as well as on rocky islands in fresh water and in the sea. It is very similar to the Arctic Tern (*Sterna paradisaea*), but the Common Tern is slightly lighter in colour and the Arctic Tern lacks the black end to its bill when in full breeding plumage.

These are beautiful birds but they are also extremely noisy, with rather shrill voices particularly in company. They are sometimes known as Sea Swallows because of their long, forked tails, reminiscent of those of swallows. Terns feed by hovering over water and then plunging down when they spot a fish below.

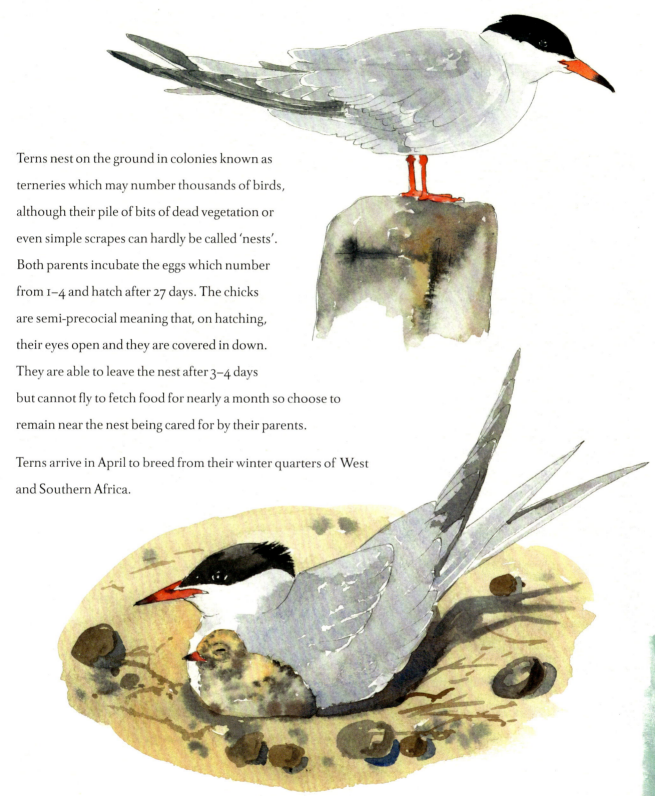

Terns nest on the ground in colonies known as terneries which may number thousands of birds, although their pile of bits of dead vegetation or even simple scrapes can hardly be called 'nests'. Both parents incubate the eggs which number from 1–4 and hatch after 27 days. The chicks are semi-precocial meaning that, on hatching, their eyes open and they are covered in down. They are able to leave the nest after 3–4 days but cannot fly to fetch food for nearly a month so choose to remain near the nest being cared for by their parents.

Terns arrive in April to breed from their winter quarters of West and Southern Africa.

Spring

Gulls' eggs

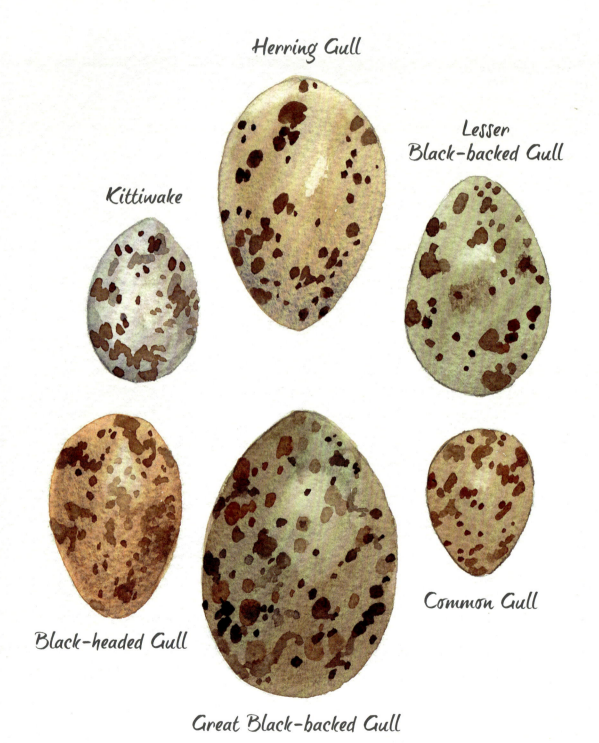

Whelks and topshells

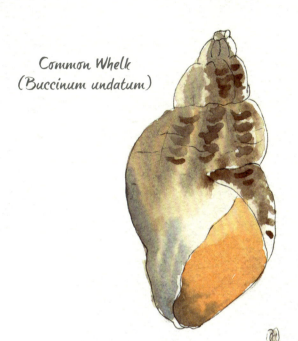

Common Whelk
(Buccinum undatum)

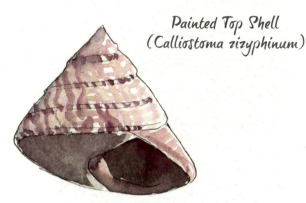

Painted Top Shell
(Calliostoma zizyphinum)

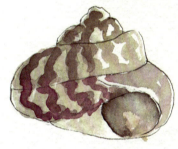

Turban Top Shell
(Gibbula magus)

Netted Dog Whelk
(Hinia reticulata)

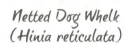

Common Wentletrap
(Epitonium clathrus)

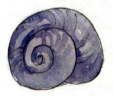

Violet Snail
(Janthina janthina)

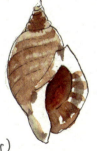

Dog Whelk
(Nucella lapillus)

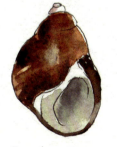

Common Periwinkle
(Littorina littorea)

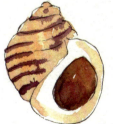

Black-lined Periwinkle
(Littorina nigrolineata)

Spring

· 49 ·

Summer

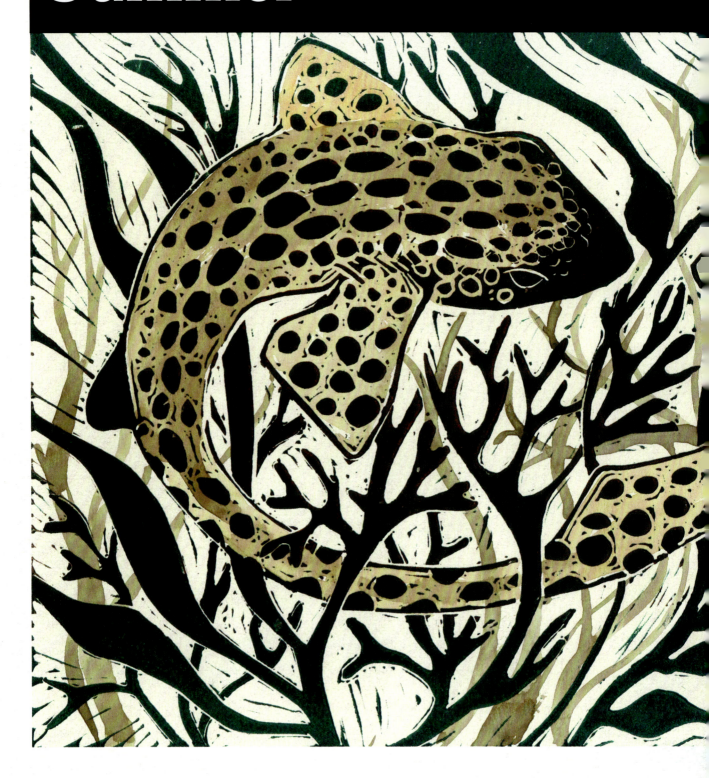

Fulmar

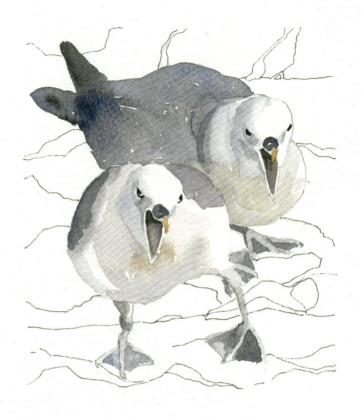

Although closely resembling a gull, the Fulmar (*Fulmarus glacialis*) is in fact a member of the shearwater family and is related to the albatrosses. It spends its life out at sea gliding on stiff wings, and only comes ashore to breed. Breeding takes place on cliffs in May, with a single egg being laid directly onto the rock ledge that has been selected. The egg takes 47–53 days to hatch – an exceptionally long incubation period.

Fulmar oil is a foul-smelling liquid that the birds are able to squirt at would-be attackers. Fulmars were very important to the population of the remote island of St Kilda. They provided food and the St Kildans used their oil in lamps. The oil was also apparently used for rubbing into aching muscles, and the birds' wings were tied together to form hearth brushes.

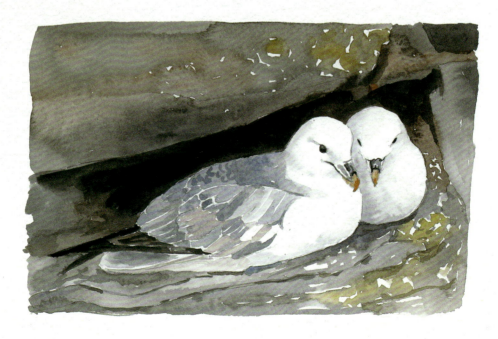

Razorbill

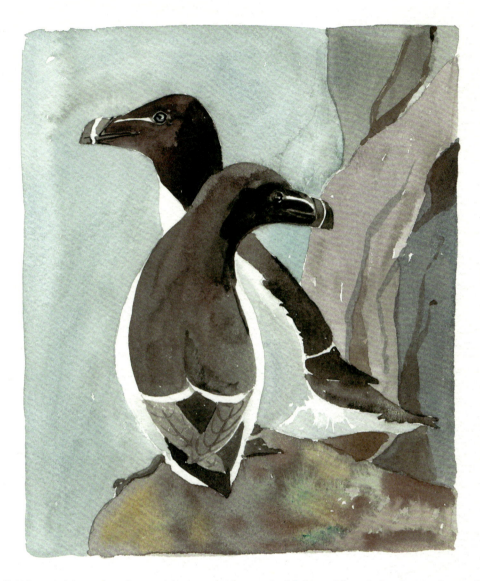

The Razorbill (*Alca torda*) is a handsome black-and-white auk. Male and female birds are identical, although the male is slightly larger than the female. The birds only come ashore to breed, spending the rest of the year out at sea, where they can dive to a depth of 120 m, using their wings to propel themselves.

Razorbills mate for life and produce one large egg each year on coastal cliffs; they often nest in large colonies. The egg is very pointed at one end, so that if it rolls it will do so in an arc and will not fall off a ledge. The parents take turns to incubate the egg, keeping it safe on their feet.

Summer

John Dory

- The rather bizarre-looking John Dory (*Zeus faber*) is unmistakable.
- Also known as St Peter's Fish.
- Grows to up to 60 cm in length and weighs up to 3 kg.
- Warm-water fish found in the Mediterranean, also occurring in southern Britain in the summer.
- Predator that feeds on smaller fish.
- Black spot on the side is supposed to look like the eye of a much larger fish to confuse predators.
- Not of commercial importance, but edible and tastes good.

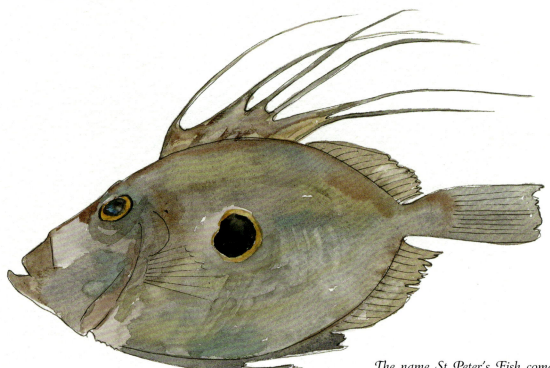

The name St Peter's Fish comes from an ancient legend. It is said that St Peter picked this fish up from the Sea of Galilee, but instead of keeping it he returned it to the water. The black mark on the side of the John Dory is said to be St Peter's thumbprint.

Limpets

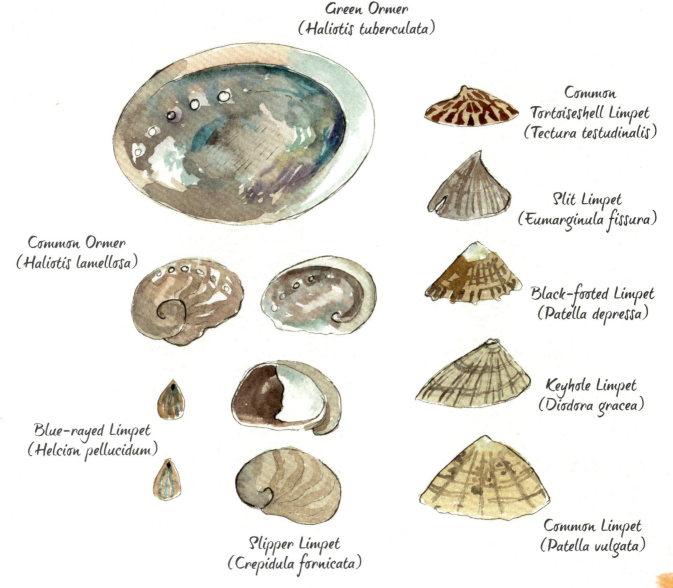

Limpets belong to the gastropod family and are molluscs that, unlike most snails, have a shell which is not coiled. They cling to smooth surfaces using a muscular foot.

The Green Ormer is a particularly large limpet found as far north as the Channel Islands and considered to be a delicacy. Its collection is strictly limited and it is illegal to take any ormers smaller than 8 cm. There are also rules about when they may be collected, which is known as ormering, and this is on specific days – the full moon, new moon and two days following between January and April.

Summer

Crabcakes with a tomato, crab and basil dressing

I am grateful to Rick Stein for allowing me to include this method of turning a humble fishcake into something exotic and delicious.

Serves 4

1 cooked brown crab, weighing about 1.25 kg

300 ml olive oil

1 large carrot, chopped

1 leek, chopped

1 medium onion, chopped

900 g potatoes

flour, for dusting

2 eggs, beaten

100 g breadcrumbs

2 tomatoes, skinned, seeded and chopped

10 fresh basil leaves, 6 thinly sliced and 4 left whole

juice of ¼ lemon

salt and freshly ground black pepper

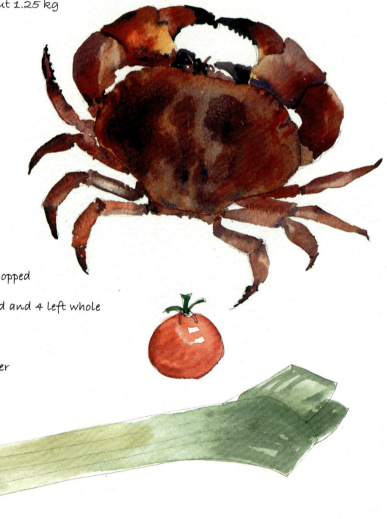

Preheat the oven to 150º C.

Extract all the meat from the crab and reserve the shells. Place the shells with the olive oil in a shallow roasting pan, together with the carrot, leek and onion. Bake in the oven for two hours to gently extract the flavour. Leave to cool, then strain the oil and discard the debris.

Cook the potatoes in lightly salted boiling water until soft. Mash with a fork and mix in three-quarters of the white crab meat, half the brown crab meat and one-third of the crab oil. Correct the seasoning with salt.

Divide the mixture into balls each weighing about 50 g. On a floured surface shape the balls into round, flat patties with a palette knife. Coat the cakes first in the flour, then the egg, then the breadcrumbs.

Put the remaining crab oil, the tomatoes, sliced basil, lemon juice and rest of the crab meat in a pan and warm through but do not boil.

Set the deep-fryer to 160º C, or heat some oil to the same temperature in a large pan. Add the cakes and fry for three minutes. Remove and drain on kitchen paper.

Divide the crabcakes between four warmed plates. Pour the dressing around the crabcakes. Garnish with a whole basil leaf placed on top of the dressing. Serve immediately.

Sea Bindweed

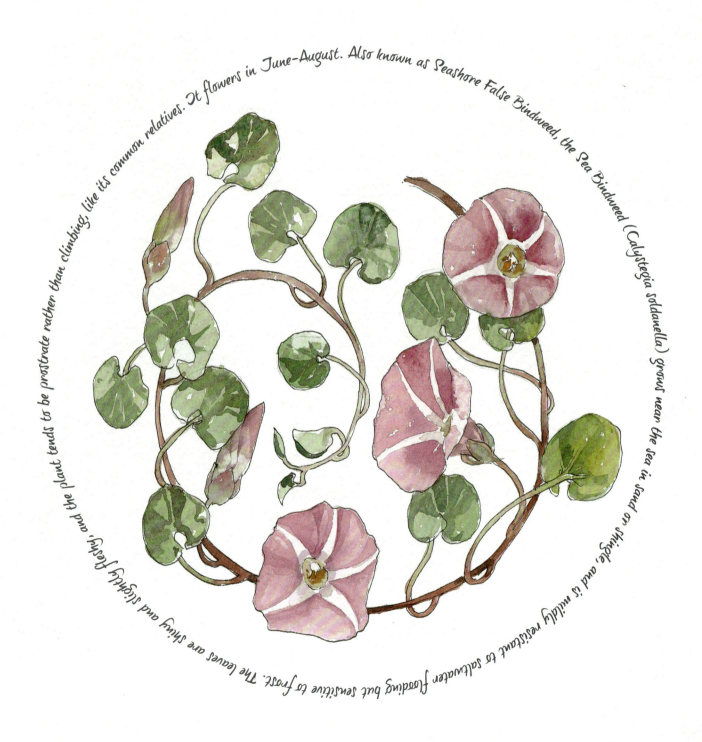

It flowers in June-August. Also known as Seashore False Bindweed, the Sea Bindweed (Calystegia soldanella) grows near the sea in sand or shingle, and is mildly resistant to saltwater flooding but sensitive to frost. The leaves are shiny and slightly fleshy, and the plant tends to be prostrate rather than climbing, like its common relatives.

Cliff-loving flowers

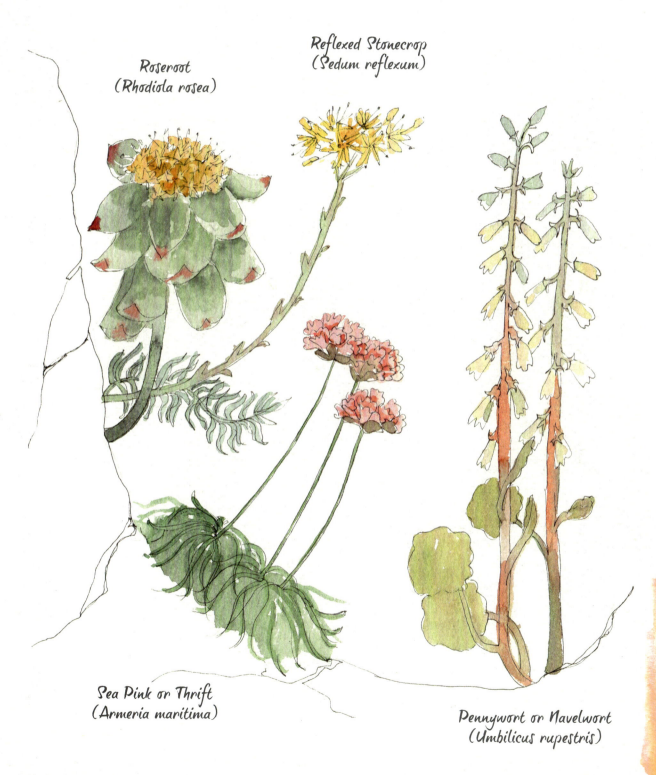

Roseroot
(Rhodiola rosea)

Reflexed Stonecrop
(Sedum reflexum)

Sea Pink or Thrift
(Armeria maritima)

Pennywort or Navelwort
(Umbilicus rupestris)

Summer

How to make pebble tablecloth weights

These are weights that you hang on the outside of a tablecloth to prevent it from blowing away outdoors. Ideally find four pebbles that already have holes in them and simply attach ring-clip hooks to them (the hooks are available for hanging curtains and are easily obtainable). If there are no pebbles with holes on the beach all is not lost – here is how to fix the wire.

YOU WILL NEED:

4 pebbles of a similar size

beading wire

packet of ring-clip hooks

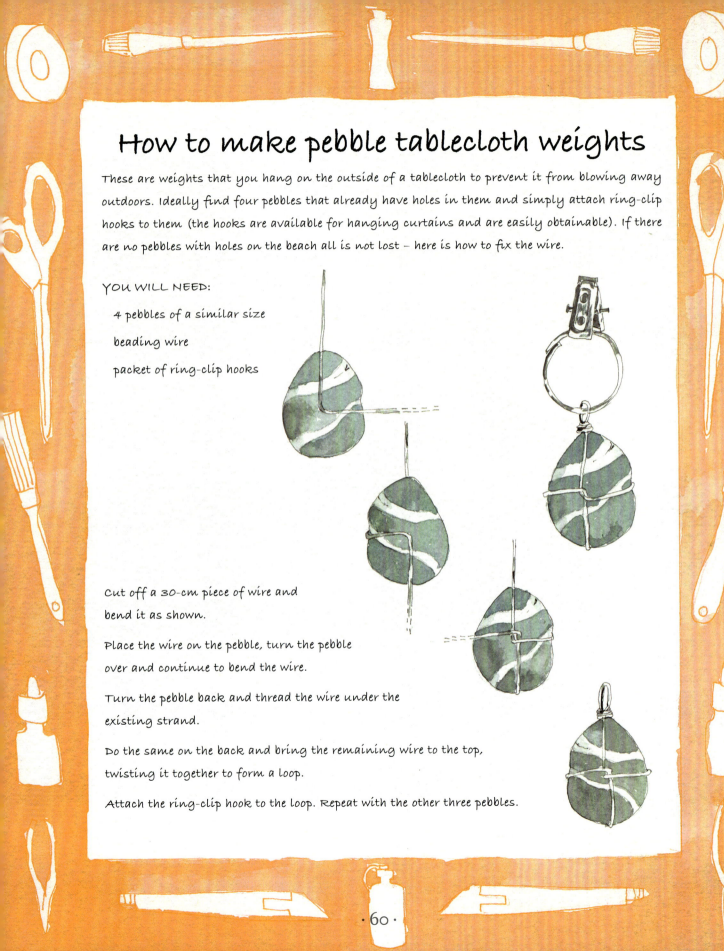

Cut off a 30-cm piece of wire and bend it as shown.

Place the wire on the pebble, turn the pebble over and continue to bend the wire.

Turn the pebble back and thread the wire under the existing strand.

Do the same on the back and bring the remaining wire to the top, twisting it together to form a loop.

Attach the ring-clip hook to the loop. Repeat with the other three pebbles.

Siphonophores

Sometimes mistaken for a jellyfish, a siphonophore differs from a jellyfish in that it is not a single organism but a colony working together. Only two siphonophore species are found in UK waters.

The By-the-wind Sailor (*Velella velella*) is 6 cm long and is mainly found in the open ocean, but is sometimes blown ashore in gales. It is bluish-purple in colour with an upright sail that twists to either left or right. It is thought that the twist results in sails ending up on different beaches, as those found together often twist in the same direction. The By-the-wind Sailor has short tentacles, and the stings are harmless to humans. Also known as the Purple Sailor.

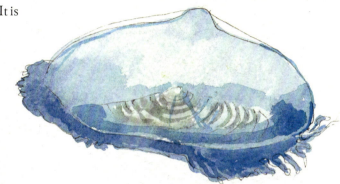

The Portugese Man-of-war (*Physalia physalis*) is 12 cm wide and up to 50 m long (although 10 m is more usual), with up to 15 cm protruding above water. It is mainly found in the open ocean, but is sometimes blown ashore during gales. It has an oval, pinkish, translucent float or bladder, and blue-and-pink, trailing tentacles that sting (see below). The stings take the form of red weals on the skin. The common name comes from the float's resemblance to the sails of the 18th-century sailing ships of the same name. Also sometimes known as the Bluebottle Jellyfish.

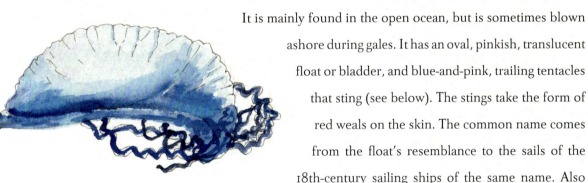

If you are stung by a Portuguese Man-of-war wash off any remaining tentacle with salt water (not fresh). Do not apply vinegar, baking soda or alcohol (and do not urinate on it), as this may make things worse. Applying shaving foam can help to prevent the spread of toxins. Apply heat to relieve the pain (use hot seawater, or if you are certain that no bits of tentacle remain, use hot fresh water). Take normal painkillers. If there is any sign of breathing difficulty or chest pain dial 999 at once.

Summer

Three divers

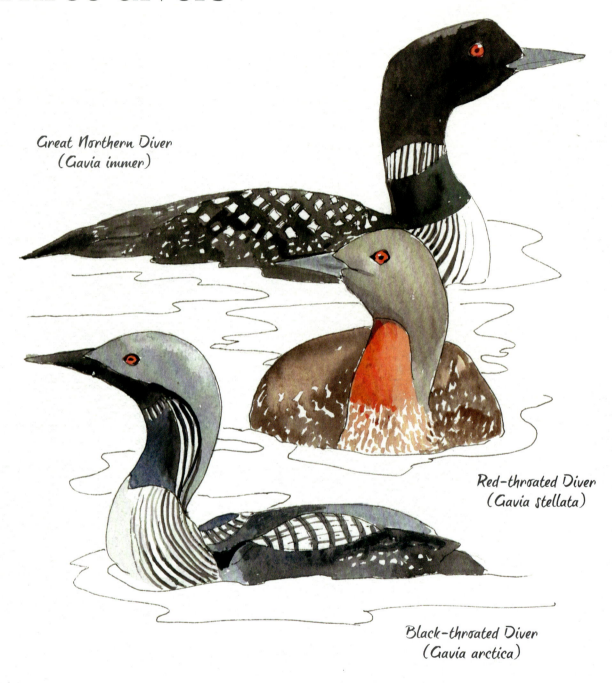

Great Northern Diver
(Gavia immer)

Red-throated Diver
(Gavia stellata)

Black-throated Diver
(Gavia arctica)

These beautiful birds are known as loons in North America, a loose description of their mournful cry. They can all be seen in northern Europe, including Scotland and the Western Isles, where they breed inland although coastal waters are their natural habitat. All lose their smart plumage in winter, becoming brown or grey.

Chitons or coat-of-mail shells

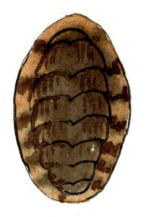

Chitons live on rocks in a similar way to limpets. The British species, which are all very small, resemble woodlice and are about the same size as them. They are distinguishable from all other molluscs by the presence of eight interlocking dorsal plates that provide protection.

Amber

You will have to look very hard to find a piece of amber and it won't be beautiful and shiny until it has been polished. What you need to look for is something that may resemble a pebble but feels light and warmer than a stone. If you are still in doubt scratch it and, if it is amber, it will burn giving off a lovely piney scent.

Amber is actually fossilised pine resin that has oozed out of a trunk and set. When still runny it is extremely sticky which is why small insects get caught inside. Interestingly it can produce static electricity when rubbed and the Greeks called it *Elektron* from which the word electricity is derived.

Summer

· 63 ·

Beach fish bake

After a hard day's fishing, what better way to enjoy your catch than to bake it on the beach? You will need to dig a hole and fill it with pebbles, build a fire on top and find some seaweed to wrap your fish in. A certain amount of forethought will therefore be required for a successful bake. You may find that you are on a beach with plenty of driftwood for a fire but no seaweed to wrap the fish in. In this case damp newspaper can be used instead. If you can find plenty of seaweed but no driftwood, you will need to have brought your own supply of charcoal. Finding the fish, of course, depends on the skill and tenacity of the fishermen.

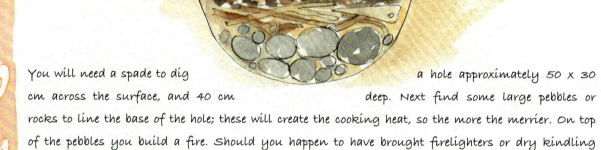

You will need a spade to dig a hole approximately 50 x 30 cm across the surface, and 40 cm deep. Next find some large pebbles or rocks to line the base of the hole; these will create the cooking heat, so the more the merrier. On top of the pebbles you build a fire. Should you happen to have brought firelighters or dry kindling from home, so much the better. Make a decent-sized fire and let it burn down, heating the rocks.

Meanwhile gut the fish and wrap them in seaweed. Use plenty of seaweed or you will end up with rather sandy, gritty fish.

Once the fire has burnt down place the wrapped fish on the pebbles, add more seaweed and cover with sand. Leave for 20-30 minutes or so – the cooking time will depend on how well you have heated the pebbles.

Before lighting fires and cooking on beaches, always make sure you are conforming with local by-laws in this respect. Remove any signs of your activities before you go, leaving the area as you found it. Also be aware of the tides in the area (see page 23).

Jellyfish

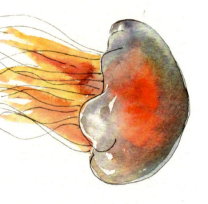

Lion's Mane Jellyfish (*Cyanea capillata*) This large jellyfish has a diameter of up to 85 cm and stinging tentacles. It comes inshore in the summer and can be quite common, particularly in the north. It can have 60 or more thin tentacles and four frilly arms in the centre.

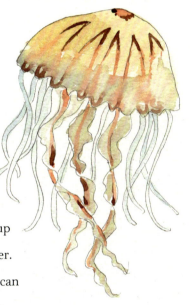

Compass Jellyfish (*Chrysaora hysoscella*) During the summer months the Compass Jellyfish can be locally common. It can grow to up to about 30 cm in diameter. The 24 stinging tentacles can cause a rash and itchiness.

Blue Jellyfish (*Cyanea lamarckii*) This rather beautiful creature is also common, particularly in the summer months. It is bluish in colour with slender, trailing tentacles and four thick arms in the centre.

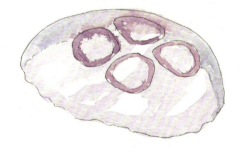

Moon Jellyfish (*Aurelia aurita*) Probably the most common jellyfish, this species will be familiar to many. It varies in size and can grow to up to 40 cm. The four circles visible on the lilac umbrella are in fact gonads (sexual glands), and there are short stinging tentacles on the edges of the 'moon'.

The body of a jellyfish consists of an umbrella-like bell with a jelly-like texture. Long tentacles hang around the bottom of the bell in the majority of species. Typical jellyfish are free swimming and move by making pulsating contractions of the bell.

Summer

Sand Lizard

- The Sand Lizard (*Lacerta agilis*) is a completely harmless species that lives on heathland and dunes.
- Grows to around 20 cm in length and may live to 20 years of age.
- Carnivorous, the diet consisting mainly of invertebrates, but will eat any small moving creature including its own young.
- Skin is a camouflage pattern of black, dark brown and beige, but during the mating season from mid-April to mid-May the male develops bright green flanks, and retains some of the green colouring during the rest of the year.
- Hibernates during winter, with the males emerging first in mid-March.
- Female lays 2–16 eggs in a shallow burrow exposed to the sun. Eggs take 8–10 weeks to hatch, relying on the warmth of the sun to do so.
- Once hatched the young lizards fend for themselves.

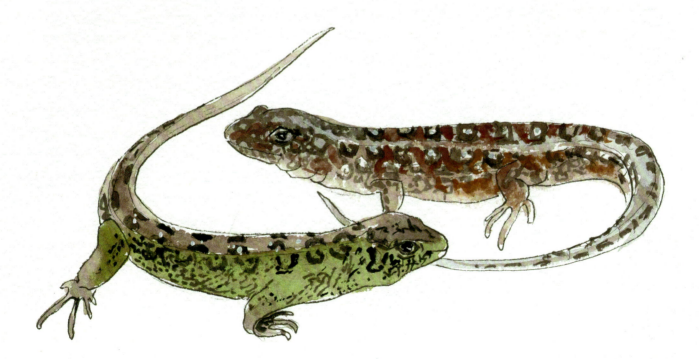

Natterjack Toad

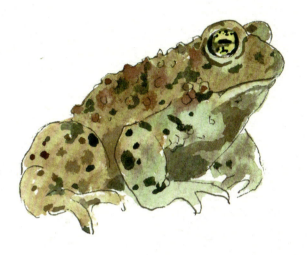
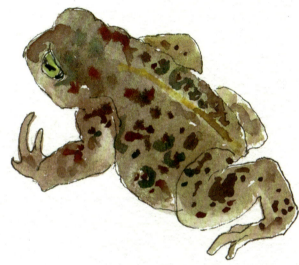

- The Natterjack Toad (*Epidalea calamita*) lives in sandy heathland, dunes and saltmarshes.
- Produces deterrent toxins from its parotid gland, although the Grass Snake (*Natrix natrix*), one of its predators, appears immune to the toxin.
- Grows to around 6–8 cm.
- Feeds on small invertebrates, flicking out its tongue, which has a sticky end to it, to catch them.
- Skin is light brown or olive-grey and covered in warts, which range in colour from red to green. Usually has a yellow stripe down the back.
- Hibernates during winter, emerging in April.
- Males arrive at breeding ponds before females, and croak every evening for several hours – the sound can be heard more than a kilometre away.
- Female lays a single string of spawn of up to 4,000 eggs, which is fertilised by the male (this differs from the Common Toad *Bufo bufo*, whose spawn string consists of a double row of eggs).
- Tadpoles hatch within 10 days and become toadlets in eight weeks.

Summer

How to make an oyster-shell fish

Certain beaches are littered with oyster shells, or of course you can simply buy oysters, eat them and keep the shells. If you use roughly 30 oyster shells, you can make a fish approximately 30–40 cm long.

YOU WILL NEED:

 about 30 flat-bottom oyster shells

 assortment of scallops and winkles

 broken limpet or similar, for the eye

 MDF or cardboard

 glue gun

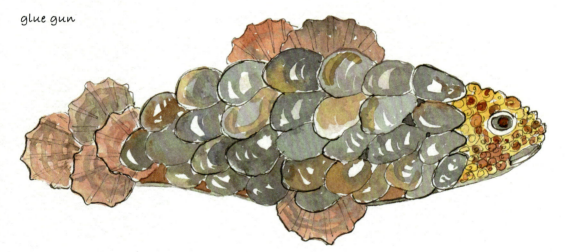

Cut out a simple fish shape in MDF, or if you prefer use cardboard. If you choose the latter, in order to make it robust enough to take the weight of the shells you will need to cut out three fish shapes. Do this in different directions across the corrugations of the cardboard for strength, and glue them together.

Start at the tail end by gluing on the scallops, then glue on the oysters in overlapping rows to form the scales, finishing with the winkles, eye and mouth. An electric glue gun will make this a simple procedure.

Skuas

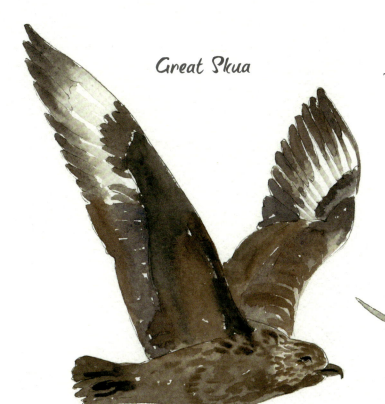

Great Skua

The **Great Skua** (*Stercorarius skua*) is a summer visitor breeding in Orkney, Shetland and the Outer Hebrides, after arriving in Britain from its wintering grounds off the coasts of Spain and Africa. It has a wingspan of 125–140 cm. It harasses birds even as large as Gannets to steal their catch for a free meal, and kills and eats smaller birds such as Puffins. It lays two eggs that take 26–32 days to incubate.

A summer visitor like the Great Skua, the **Arctic Skua** (*Stercorarius parasiticus*) also harasses other birds for their catches and kills small birds. It can be seen flying low and fast just above the waves in pursuit of another bird. It has a wingspan of 118 cm, and lays two eggs that take 25–28 days to incubate.

Arctic Skua

The Orkney and Shetland name for the Great Skua, Bonxie, may derive from an old Norse word meaning dumpy, which refers to the birds' rather heavy-set build and habit of dive-bombing anyone foolish enough to approach their nests.

Summer

Shrimps and prawns

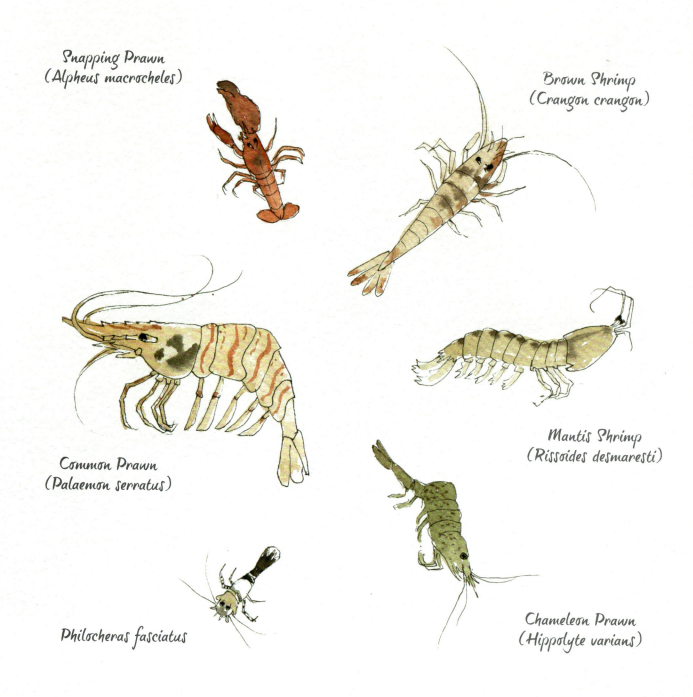

June flowers that grow in shingle

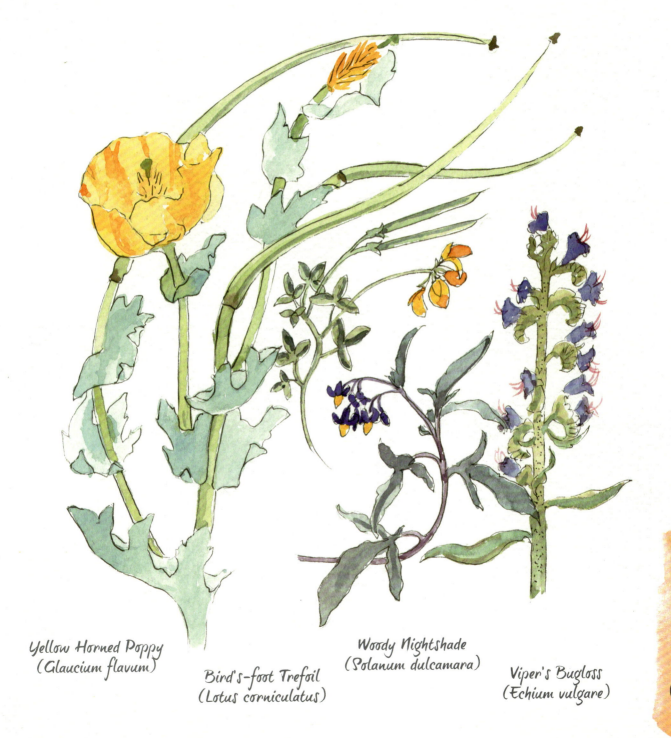

Yellow Horned Poppy
(Glaucium flavum)

Bird's-foot Trefoil
(Lotus corniculatus)

Woody Nightshade
(Solanum dulcamara)

Viper's Bugloss
(Echium vulgare)

Summer

Spaghetti with clams

I am indebted to Mitch Tonks for allowing me to include this recipe from his book *Fish*. Known as spaghetti vongole in Italy, it is simplicity itself but to my mind one of the most delicious ways of serving pasta.

Serves 2

 3 handfuls of good-quality dried spaghetti

 2 handfuls of clams

 pinch of salt

 100 ml extra-virgin olive oil

 2 large cloves garlic, crushed

 1 bay leaf

 1 handful of fresh parsley, chopped

 1 dried red chilli, finely chopped

 1 fresh tomato, skinned

 2 good glugs of white wine

 20 g butter

 lemon wedge, to serve

Bring a large pan of water to the boil, and add a good pinch of salt, then the spaghetti. The clams will cook in the same time as the spaghetti.

Put the oil in a frying pan, heat gently, then add the garlic, bay leaf, some of the parsley, and dried chilli, and squeeze the tomato into the mixture.

Now add the clams to the pan and give the ingredients a good stir, turning the clams over so they become coated in the ingredients. Make sure the garlic does not burn.

Next, add the white wine and a bit more fresh parsley. Turn up the heat slightly, and wait for the clams to steam open – they will release loads of fabulous juice into the pan. If the clams take some time to open, do not let them fry; just add a splash of water to create some steam to help them along. Remove any clams that have not opened.

Check that all the spaghetti has separated in the boiling water and stir it around briefly. You will know when it is done by tasting it. The pasta should not be soggy. It should still have a bit of 'bite' to it in the middle.

Take the clams from the heat, add the spaghetti and toss together. Add the butter and toss the ingredients again. Serve with the lemon wedge.

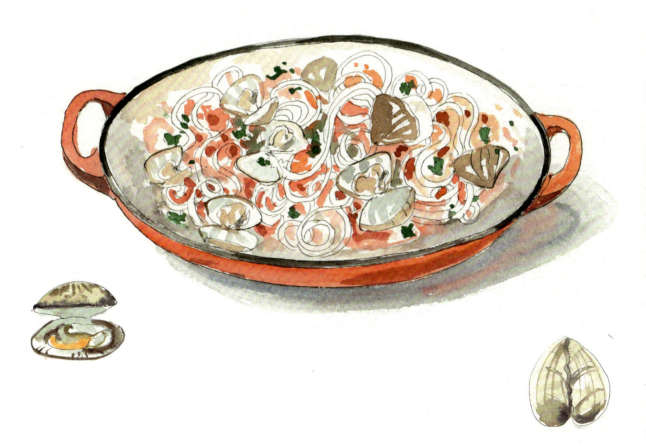

Gannet

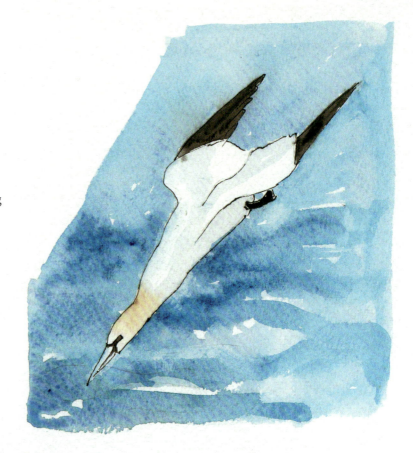

The Gannet (*Morus bassanus*) is a large and exceptionally handsome bird built for diving into the sea after its prey. It does this from a height of some 30 m, reaching speeds of up to 100 kph – deeper than many other diving birds. With a wingspan of 2 m, Gannets are also strong fliers, folding their wings back at the last minute before they hit the water.

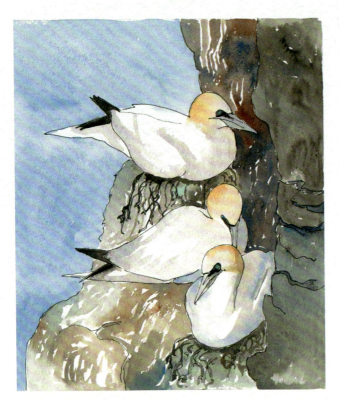

Gannets nest in colonies, and around two-thirds of the world population nests in the United Kingdom, choosing coastal cliffs and remote islands as breeding sites. Some colonies run to as many as 150,000 birds, with each pair laying a single egg. Both parents take turns to incubate the single egg for up to 45 days, and it can then take the chick an entire day to peck its way out of the particularly thick shell. The chick has an immense appetite and keeps both parents busy. The colonies are crowded, with up to three nests per square metre, and any birds whose nests are in the centre have to walk through and over adjoining nests to be able to take off at a cliff edge, causing consternation and aggression among birds that they pass.

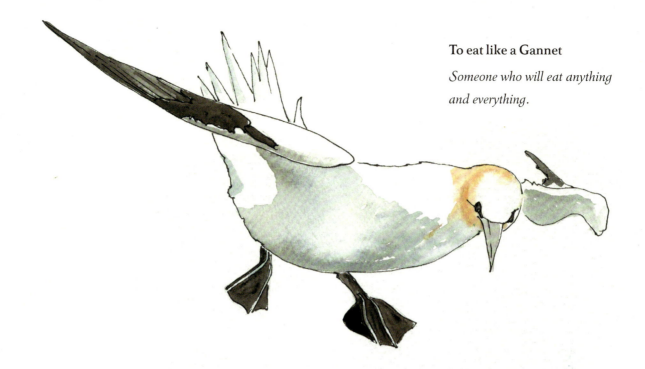

To eat like a Gannet

Someone who will eat anything and everything.

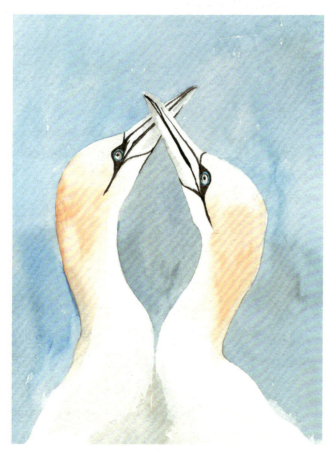

After 75 days the chick has grown enormous and is heavier than its parents, and it leaves the nest although it cannot yet fly. It takes a leap of faith and tumbles into the sea, and now has to fend for itself even though it may not fly for another month. Juveniles are speckled brown at first and do not gain their full white plumage until they are five years old. Both sexes look the same.

Gannets do not have external nostrils – their nostrils are inside their bills to aid underwater pursuit of prey.

Summer

Common crabs

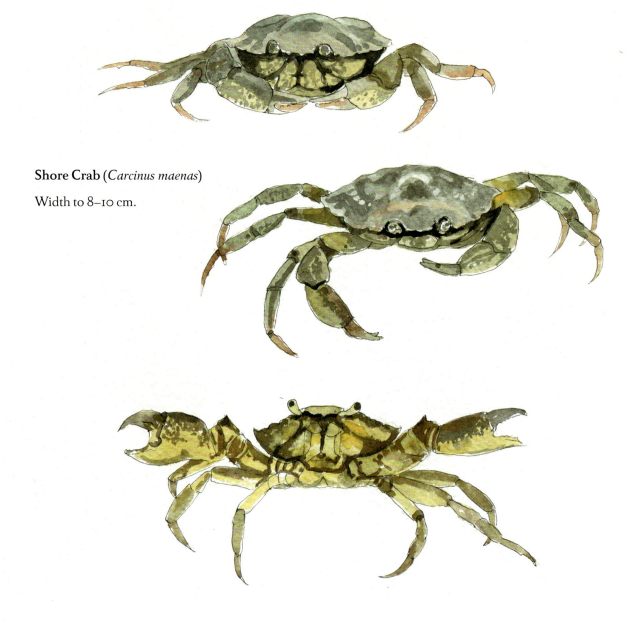

Shore Crab (*Carcinus maenas*)

Width to 8–10 cm.

Crabs are characterised by their tough shell, or exoskeleton, known as a carapace. They have five pairs of legs, the front ones being the largest, with pincers. In order to grow crabs have to moult, which they manage by crawling backwards out of the carapace, leaving behind a perfect shell that even includes the gills, or dead men's fingers.

When they have just emerged they are known as peelers, and they are vulnerable to predators until their new and larger shell forms. The different species of hermit crab do not grow a carapace at all but use a seashell for protection, moving into a larger model as needed.

Common or **Edible Crab**
(*Cancer pagurus*)
Width to 20–30 cm.

Velvet Swimming Crab
(*Necora puber*)
Width to 6–8 cm.

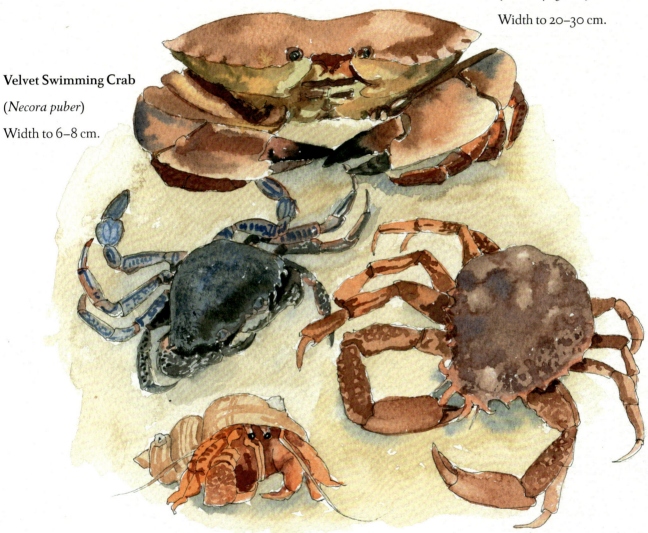

Common Hermit Crab (*Pagurus bernhardus*)
Width to 3 cm.

Spider Crab (*Maja squinado*)
Width to 20 cm.

Crabs' eggs grow on the female's abdomen and may stay attached for up to four months before being released – in this state the female is described as 'berried'.

Summer

Laverbread, cockle and bacon quiche

Many thanks to the Pembrokeshire Beach Food Company for letting me include this unusual recipe. Laverbread is available tinned, but if you want to make your own you need to obtain laver, the strange seaweed that totally coats the rocks at low tide. Collect a kilo or so, wash several times in fresh water, then boil for at least six hours or overnight in the bottom oven of an AGA – you will end up with a dark mush that can only be described as looking like a cowpat. Fortunately the taste will be of the sea.

Serves 4

For the shortcrust pastry

- 50 g butter
- 50 g lard
- 200 g plain flour
- pinch of salt
- cold water

For the filling

- 200 g bacon
- 200 g laverbread
- 200 g cockles
- 2 eggs
- 2 egg yolks
- 200 ml cream
- salt and pepper

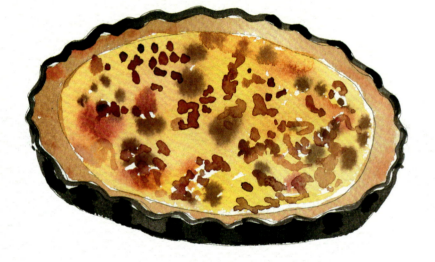

Make sure that the fat is at room temperature and soft enough for a knife to easily cut through it. This will help when it comes to mix the flour and fats together.

To make the pastry, sift the flour into a bowl and add a pinch of salt. Cut the butter and lard into small lumps and add to the flour. Use the knife to blend together the mixture, then use your fingertips to crumble it until it resembles breadcrumbs.

Add a drop of cold water a little at a time, and use a knife to blend it in. Once the mixture starts

coming together do not add any more water. The dough should come out of the bowl cleanly. Rest it in the refrigerator for a minimum of 30 minutes. This helps the gluten in the flour react with the water and makes the pastry more elastic, which helps in rolling it out.

Preheat the oven to 180º C.

Dust a surface with flour and rub a rolling pin with flour, before rolling out the dough on the surface to around 3 mm in thickness.

Place the rolled-out dough in a 30-cm flan dish. Cover with greaseproof paper and put uncooked baking beans, dried pulses or rice on top of the paper to keep the pastry down while cooking. Blind bake by placing the dish in the oven for 15 minutes, or until the pastry is golden.

While you are blind baking the pastry, make the filling. Chop the bacon into small pieces and put in a frying pan. Heat over a low heat and once the juices from the bacon start flowing, add the laverbread and mix with the bacon and juices. Once the bacon and laverbread mixture have cooked (usually around 5 minutes), remove from the heat and let them cool.

Mix the cockles into the bacon mixture and season to taste.

Combine the eggs in a jug, then add the cream and mix again.

Place the cockle, laverbread and bacon mixture on top of the now-golden pastry, and pour the egg and cream mixture on top. Mix together with a fork, then place in the oven and cook for around 30–40 minutes.

Serve hot or cold.

Green seaweeds

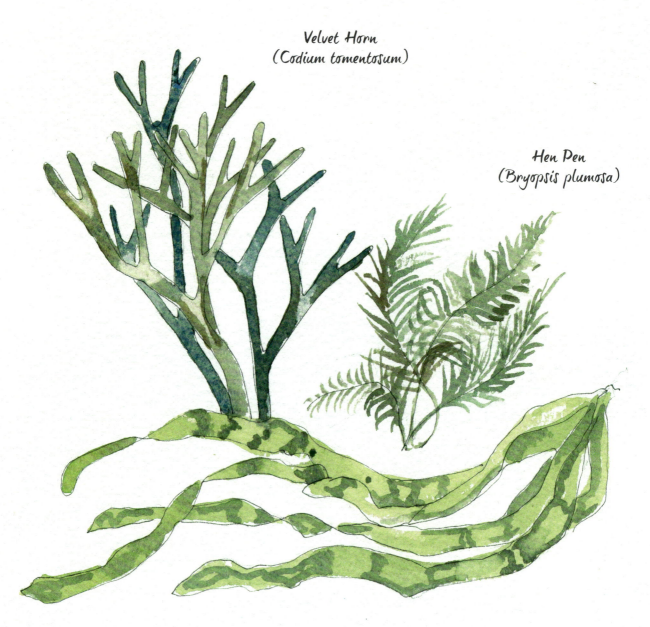

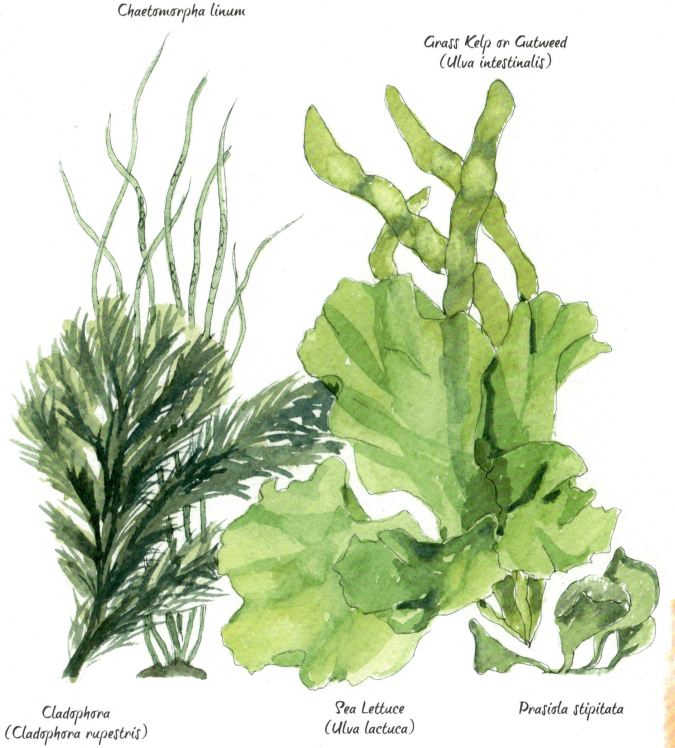

July flowers

Greater Burnet
(Sanguisorba officinalis)

Brown Knapweed
(Centaurea jacea)

Tufted Vetch
(Vicia cracca)

Hedge Bedstraw
(Galium mollugo)

Common Toadflax
(Linaria vulgaris)

Dyer's Greenweed
(Genista tinctoria)

Red Valerian or Kiss-me-quick
(Centranthus ruber)

Marsh Woundwort
(Stachys palustris)

Moths found on coasts

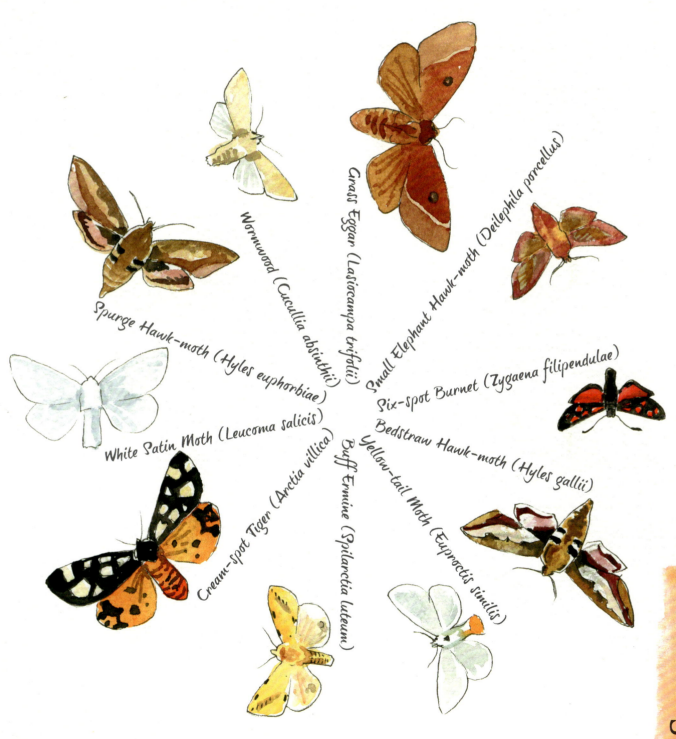

Summer

How to make a magnetic fish game

YOU WILL NEED:

cardboard, felt or other material

washers

length of string

magnets

4–6 small pieces of bamboo

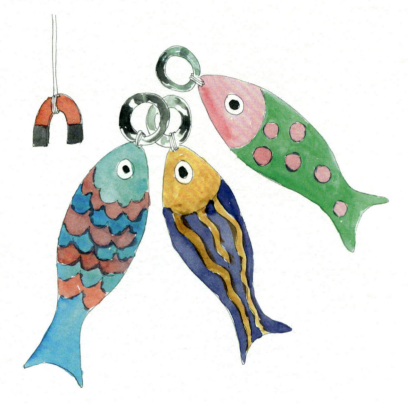

Cut out a fish shape from cardboard, felt or any old material.

Attach a washer either by gluing it or by stitching it on to the fish's nose.

Make the rods by attaching a length of string with a magnet on one end to each piece of bamboo.

The game can be played in several ways: very small children will simply be happy fishing and seeing who can catch the most fish. For larger children each fish can have a score, either by colour, such as red = 5 and blue = 2, or by numbers written on the underneath. For all ages a forfeit could be on the underneath, with participants taking turns in catching a fish.

Sea Scorpion

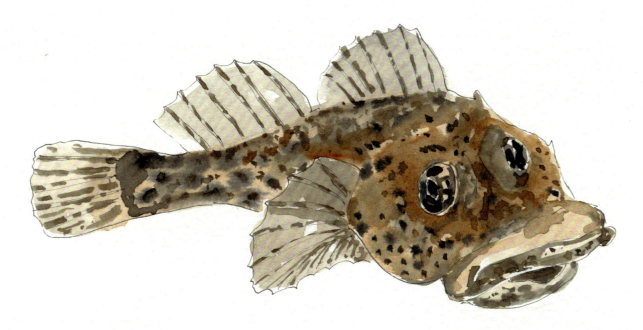

Sea Scorpion

The rather terrifying-looking Sea Scopion (*Myoxocephalus scorpius*) grows to 45 cm (18 in) in length and can weigh as much as 1½ kg (3 lb). This is just one of a vast family of scorpion fish worldwide numbering over 200 species. Some scorpion fish are exceptionally poisonous; the two species that inhabit UK waters are not, however they do possess a fine armoury of spines that they use in defence.

Sea Scorpions have a voracious appetite and eat anything they can find, including fish as large as themselves. Their skin is scale-less and the sexes can be distinguished easily as the male's skin is usually red while the female's is orange.

Only one other species of Sea Scorpion is found in UK waters – the Long-spined Sea Scorpion *Taurulus bubalis* – which looks very similar but is considerably smaller.

Summer

Puffin

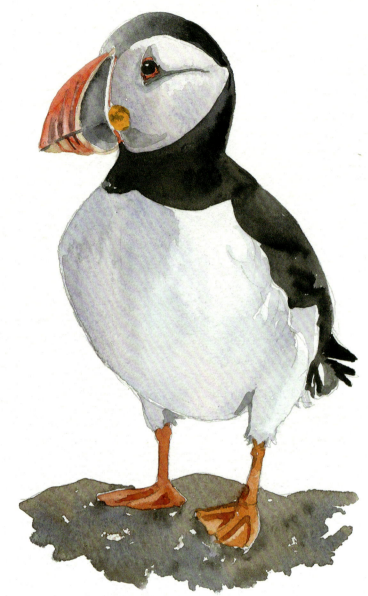

- The Puffin (*Fratercula arctica*) is a charming and distinctive member of the auk family, or Alcidae.
- Also known as the Sea Parrot, and often described as the clown of the sea.
- Mainly pelagic, only coming ashore to breed and doing so on turf-covered cliffs in large colonies.
- Their remarkable bill becomes brightly coloured during the breeding season, but reverts to a dull shade during winter.
- Puffins are excellent swimmers and use their wings to 'fly' underwater.
- Although they mostly hunt at shallower depths, Puffins can dive to depths of 50 m and, thanks to muscles rich in myoglobin, they are able to dive as deep as 60–70 m, staying underwater for as long as 5 minutes.

- Puffins' eggs are laid in burrows that they dig out using the bill and feet, but they are also happy to take over convenient rabbit holes.

- Pairs generally remain together and return to the same burrow every year.

- Although Puffins grow two brood patches (areas of featherless skin that transfer heat to incubating eggs) females lay just a single egg, which both parents take turns incubating.

- Pufflets are fed mainly on sandeels.

- The bill of a puffin is serrated to help it hold the sandeels facing in opposite directions.

- Average sandeel catch per trip is 10, but the astonishing record is more than 60 in one go.

- For small birds, Puffins live remarkably long lives: the oldest recorded Puffin was a 41-year-old on the Norwegian island of Røst. Unlike humans, however, they show no outward signs of old age, so OAPs (old age Puffins) are hard to spot.

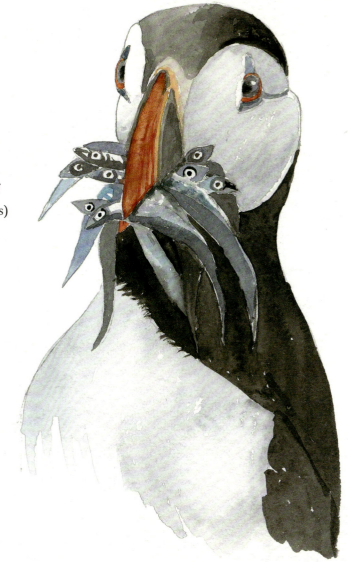

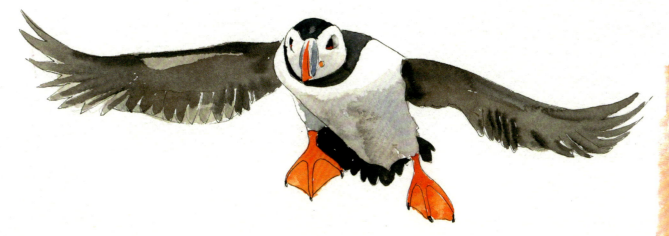

Summer

Coast-inhabiting butterflies

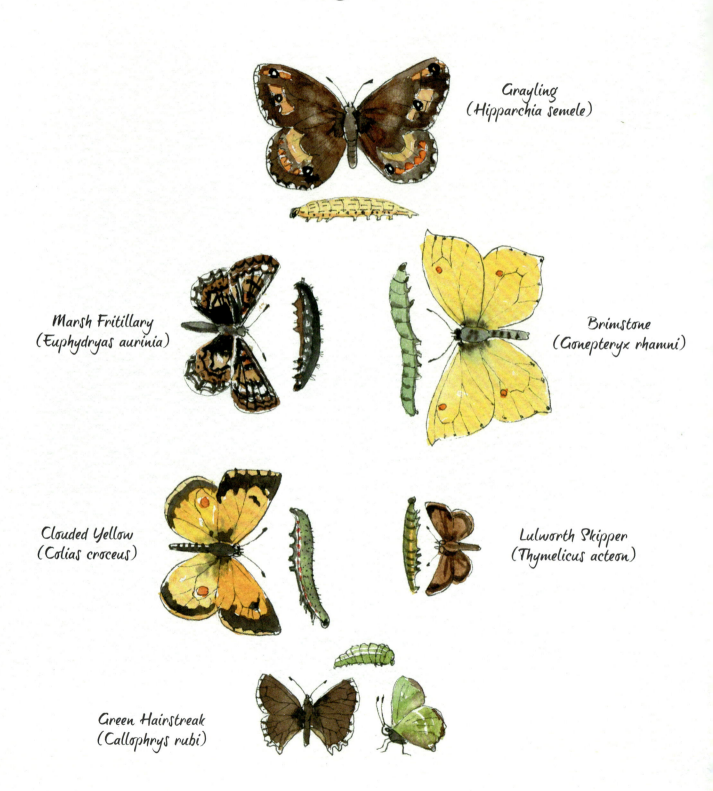

Marbled White
(*Melanargia galathea*)

Wall Brown
(*Lasiommata megera*)

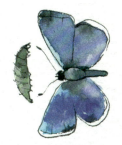

Common Blue
(*Polyommatus icarus*)

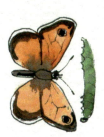

Small Heath
(*Coenonympha pamphilius*)

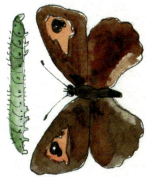

Meadow Brown
(*Maniola jurtina*)

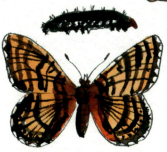

Glanville Fritillary
(*Melitaea cinxia*)

Summer

· 93 ·

Henny's seaside monkfish wraps

This recipe makes for a great picnic supper for that sunny summer evening on the beach. Inspired by Mexican food, it takes a bit of effort to make the dish, but everyone will agree that it is well worth it. The habanero sauce can be made at home and refrigerated until ready for use.

Serves 6

For the wraps

 6 monkfish steaks (or 500 g monkfish tail cut into steaks)

 1 quantity habanero hot sauce (see method opposite)

 1 tin refried beans

 6 tortilla wraps

 150 g guacamole

 big bunch of coriander

 juice of 2 limes

Preheat the barbecue.

Brush the monkfish steaks with a little of the habanero hot sauce and grill on the barbecue for 3–5 minutes on each side.

Reheat the refried beans on a camp stove.

Make up the wraps with a fish steak, a dollop of refried beans, a blob of guacamole, a pinch of coriander, a squeeze of lime juice and as much hot sauce as you can handle.

Preheat the grill to a medium heat.

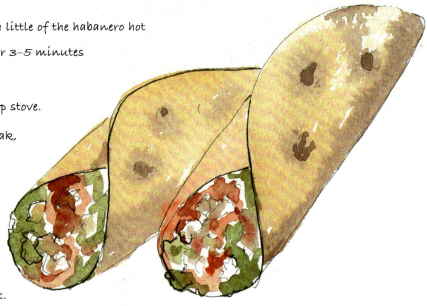

For the habanero hot sauce

- 1 habanero pepper (2 if you are feeling very, very, very brave)
- 2 large carrots, peeled and cut into 4-cm pieces
- 1 yellow onion, peeled and cut into eighths
- 3 cloves garlic (skin on)
- 2 tbsp olive oil
- 1 tsp sugar
- 2 tsp salt, plus more to taste
- handful of coriander leaves
- juice of 2 limes
- 60 ml apple cider vinegar (plus more as needed)
- 60 ml water (plus more as needed)
- salt

Arrange the carrots, onion and garlic on a rimmed baking sheet, and drizzle with olive oil to evenly coat them. Sprinkle with sugar and salt.

Grill until the vegetables are soft and slightly charred, turning occasionally. Remove the vegetables individually as they are done, noting that the carrots will take the longest (15-20 minutes).

While the vegetables are cooling, steam the peppers in a bag. After about 10 minutes, using gloves carefully remove the skin from each pepper.

Remove the garlic cloves from their skins, and add the cooled vegetables to a food processor fitted with a steel blade. Add the coriander and lime juice, and pulse until everything is finely chopped, scraping down the sides of the bowl as necessary. Add vinegar and water and process until smooth. Add additional vinegar and/or water as needed to form a thick sauce, tasting as you go. Season to taste with additional salt.

Transfer the sauce to an airtight container and store in the refrigerator until ready for use.

Atlantic Mackerel

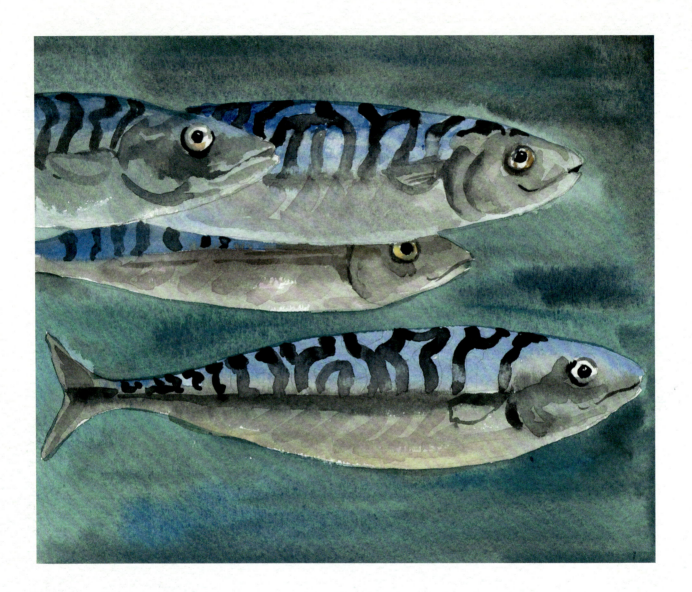

The beautiful, almost tropical-looking Atlantic Mackerel (*Scomber scombrus*) is common around the UK in the summer months and popular with anglers. It grows to up to 45 cm in length and 2 kg in weight, and its streamlined shape helps it to be a speedy hunter of small fish and sandeels. In fact it is the fastest swimming fish in European waters, and can cover 50 m in an astonishing 10 seconds.

*Mackerel scales,
furl your sails.*

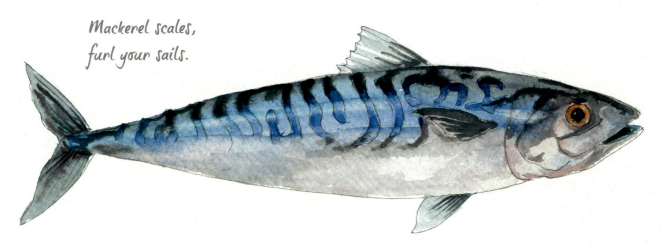

Mackerel can be caught from the shore using feathers, daylights or spinners; if the water is deep enough even a handline with a baited hook will be successful. Feathers and daylights are available with up to six hooks on the line, and as mackerel often swim in shoals six fish can be caught at the same time.

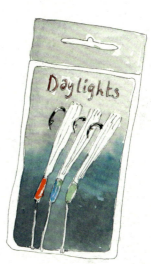

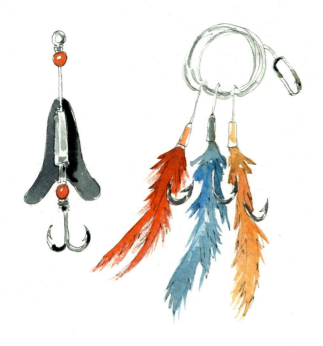

God grant that I may live to fish
Until my dying day,
And when it comes to my last cast
I then most humbly pray
When in Lord's safe landing net
I'm peacefully asleep
That in His mercy
I be judged
As good enough to keep

Anonymous

Summer

· 97 ·

Sea Holly and Sea Lavender

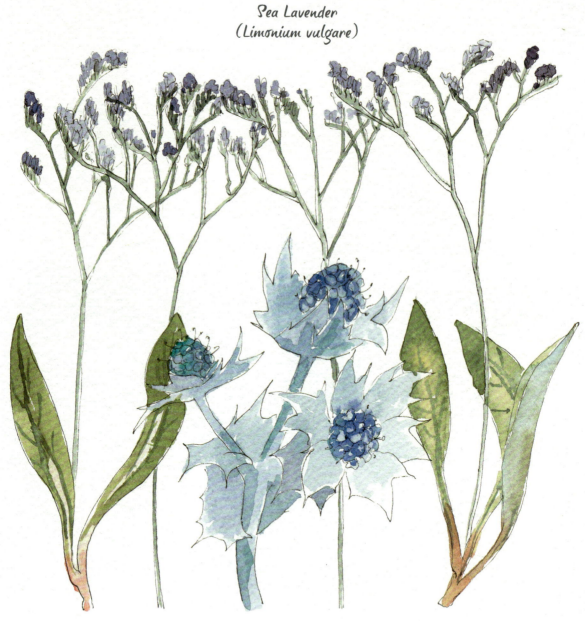

Common estuary flowers

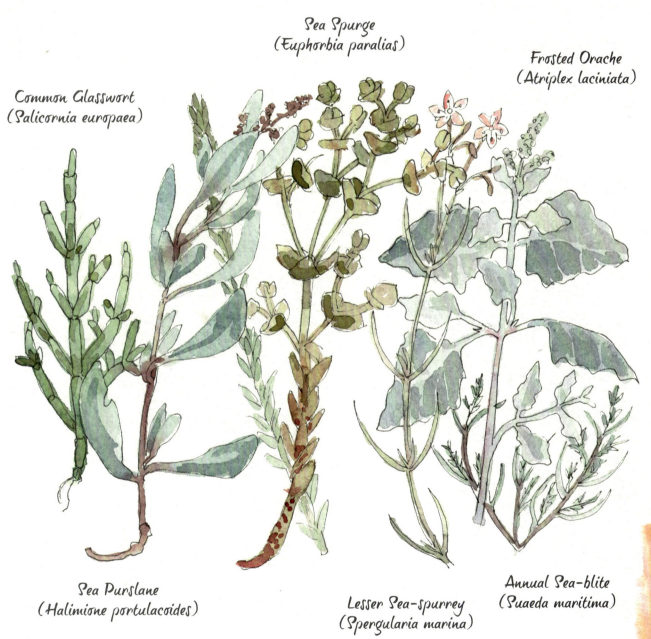

How to make a driftwood seahorse

A seahorse has a distinct but simple outline, ideal for making a driftwood sculpture.

YOU WILL NEED:

- lots of small, straight pieces of driftwood of varying lengths
- large piece of cardboard
- small piece of parcel tape and string (to make a hanger)
- glue gun

Draw an outline in the shape of a seahorse on the cardboard. Do not make it too small — it should be about 70 cm from top to bottom or larger.

Stick two pieces of parcel tape across, 30 cm from the top, and make two holes. Thread a piece of string through the holes and tie — this will be used to hang your masterpiece on the wall when it is finished.

Cut out the design and lay out the driftwood on it.

If at this point you realise you have not collected enough driftwood, you may have to reduce the size of the sculpture.

Using the glue gun and starting at the top, glue the driftwood pieces onto the template.

Make an eye from anything suitable you can find — a limpet with a hole in it filled with a winkle works well, but even a pebble is fine.

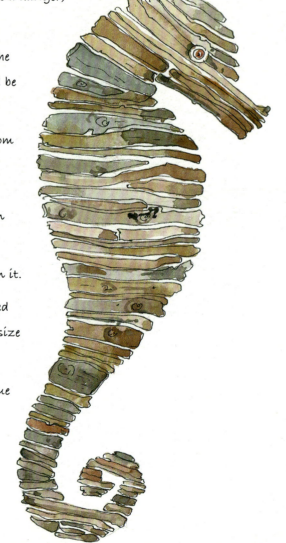

Scallops

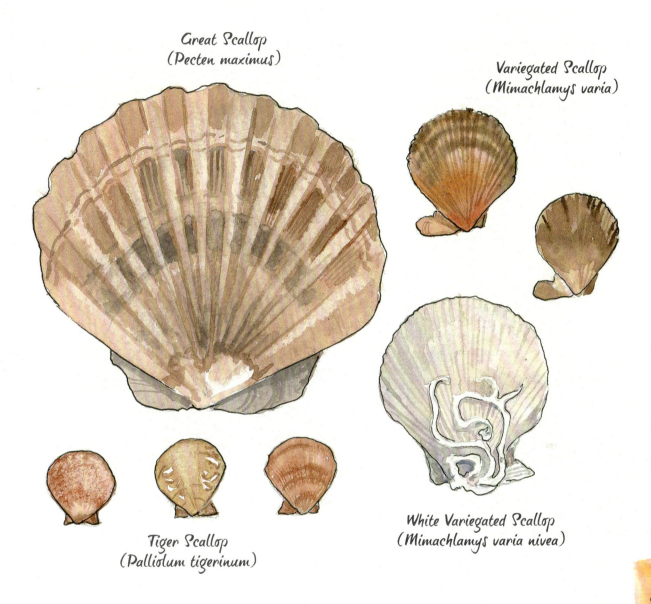

Scallops are a large family of marine bivalves found in oceans all over the world but never in freshwater. They are edible and delicious. The two shells are slightly different in shape, one being flatter and the other convex, and the animal generally rests on its flatter side. By opening and quickly closing their shells they can propel themselves hinge first in a jerky motion.

Summer

Sandeels

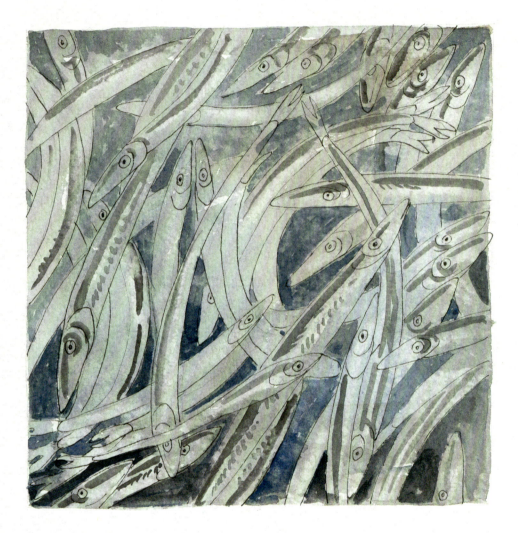

Two species of sandeel are widely found in the coastal waters of the United Kingdom: the Lesser Sandeel (*Ammodytes tobianus*) and the Greater Sandeel (*Hyperoplus lanceolatus*). They are very similar, and both are more common in the south than in the north.

Sandeels are an extremely important food fish for a number of marine predators, including many species of bird and fish. They are small, eel-like fish that swim in large shoals. They spend the winter in burrows in sand, rarely emerging except to spawn in December and January. Their active feeding time is from April to September, when they emerge during daylight hours to forage for zooplankton and small fish.

Lobster Moth

Lobster Moths (*Stauropus fagi*) have absolutely no connection with the sea, but are so named because the fantastic larvae supposedly resemble lobsters. The moth itself is a member of the prominent moth family, and is dark greyish-brown with a furry appearance. The caterpillar has extra-long front legs (known as true legs), and when alarmed it rears up, waving its long forelegs to imitate a spider. If this does not frighten off the attacker, it has a second line of defence as it is able to squirt formic acid.

Common Restharrow

The Common Restharrow (*Ononis repens*) is a pretty creeping plant of the Leguminosae family that particularly loves coastal areas. It flowers later in the year than most leguminous flowers, being in bloom from July to September.

Summer

Autumn

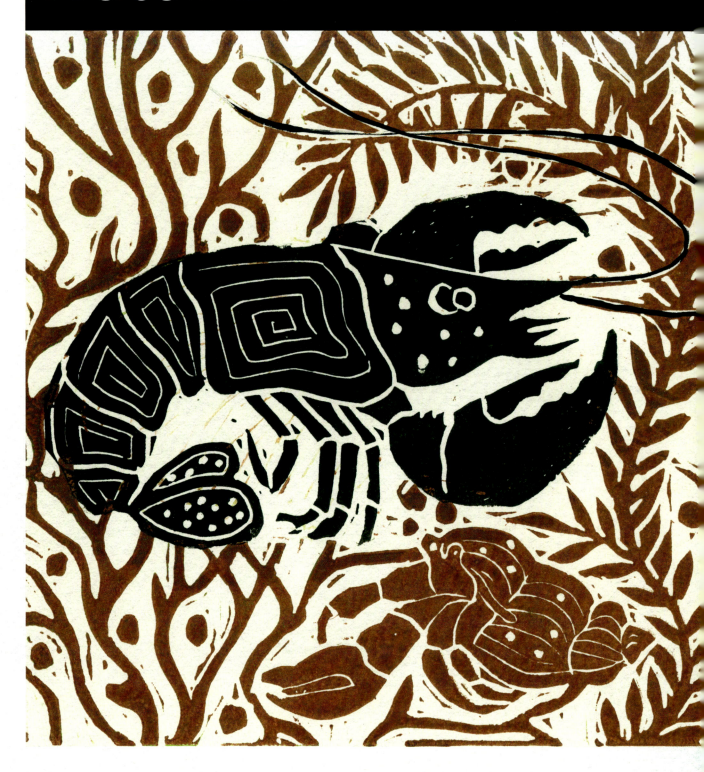

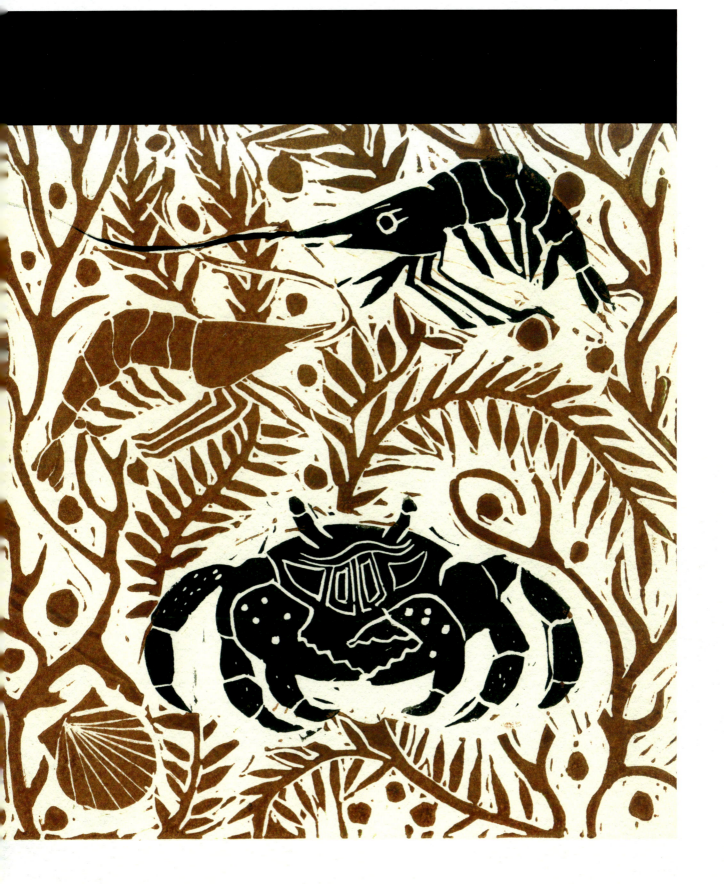

Is it a Dover Sole or a Lemon Sole?

Dover Sole

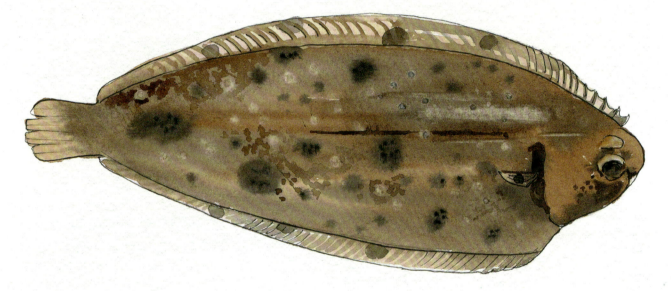

- *Solea solea*
- Dover Sole is also known as Common Sole and Black Sole
- Grows up to 3ft and 7lb, but more typically weighs 1–2lb
- Can be caught from the shore
- Feeds on marine worms, prawns and invertebrates
- Right-eyed, oval-shaped, with small tail
- Found on sand and shingle seabeds
- Seeks deeper water in winter but comes into shallower water to feed and spawn
- Inactive during the day feeding more at night

In the 19th century there was huge demand for Dover Sole from the people of London and a regular stagecoach service ran several times a day to transport the fish from Dover to the capital.

Lemon Sole

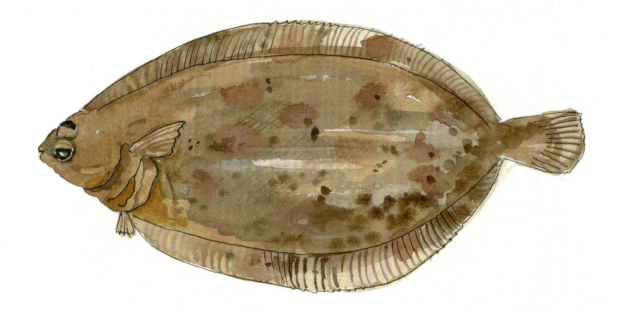

- *Microstomus kitt*
- Grows up to 2ft and 7lb
- Not often caught from the shore
- Feeds on marine worms, prawns, crabs and shellfish
- Left-eyed, oval-shaped, with white underside and slimy skin
- Lives in deeper water than the Dover Sole down to depths of 200m

There are many suggestions for how this fish got its name. Is it because its shape is reminiscent of a lemon? Or is it perhaps from the French word 'limon' that means 'silt'?

Autumn

White-tailed Eagle

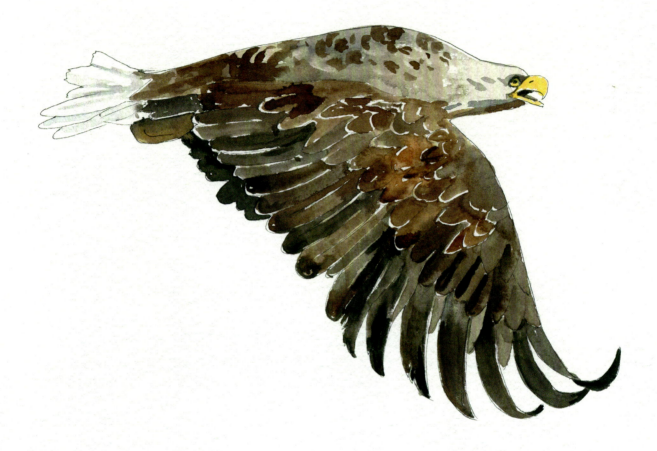

The magnificent White-tailed Eagle (*Haliaeetus albicilla*) is the UK's largest bird of prey. Its head and neck are pale in colour, becoming almost white in older birds, and the tail feathers of adults are white. The wingspan is up to an amazing 2.45 m. The species became extinct in the UK in the early 20th century and the birds now to be seen on the west coast of Scotland have been reintroduced from the Continent via Rhum.

Birds typically form pairs from the age of five and are strictly monogamous, although if one of a pair dies a replacement is found. Their large nests are built in trees from sticks, and are often used year after year.

Fulmars are one of the eagles' favourite foods, but they also eat carrion. Fish are, however, their main diet and they are expert fishermen. They fly low over the water, be it a loch or the sea, and snatch any unwary fish that comes up to the surface. They hold their prey with one foot, often taking a bite from it while in flight.

How to make a driftwood candelabra

For this you will need odd-shaped bits of driftwood, the twistier the better. The candelabra can be any size, with any number of candles — make sure that the base is absolutely stable before lighting up the candles.

YOU WILL NEED:

- driftwood
- small jam-jar lids (approximately 5 cm), hole punched in the middle of each, to act as candleholders
- ½-cm screws
- glue gun (or use superglue with care)
- spirit level
- small saw
- plastic wood filler
- screwdriver
- tealight candles

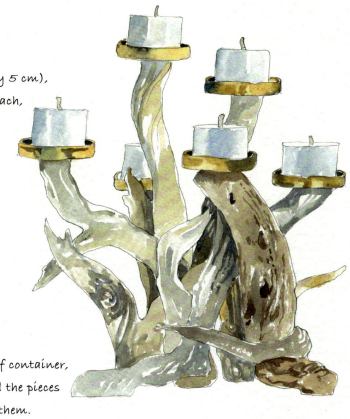

Try out your design in some sort of container, such as a saucepan, which will hold the pieces balanced more or less as you want them.

Mark a line on the driftwood where a candleholder will be.

Saw the tops off along the line you have drawn.

Glue the bits together (four hands will make this considerably easier).

Stand the candelabra up. Using a spirit level, check that the surface you fix the candle holder to is level — most likely it will not be, so using plastic wood build it up until it is.

Screw the jar lids into place using the small screws and sit the candles on top.

Dandelion clocks

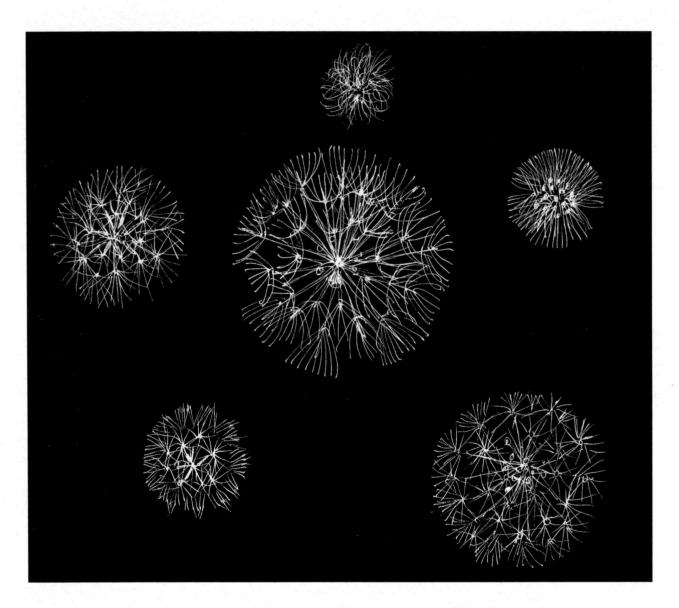

From top, clockwise:

Common Sow Thistle (*Sonchus arvensis*)

Mouse-eared Hawkweed (*Pilosella officinarum*)

Dandelion (*Taraxacum officinale*)

Common Cat's Ear (*Hypochaeris radicata*)

Rough Hawk's-beard (*Crepis biennis*)

Centre:

Goat's Beard (*Tragopogon pratensis*)

Ballan Wrasse

Ballan Wrasse (*Labrus bergylta*) grow to almost 1 m in length and can weigh up to 5 kg, but are more likely to be around 1 kg. There is a minimum size at which a wrasse can be taken, which is 23 cm. The fish frequent rocky inshore coastal areas all around the UK. They feed on a variety of shellfish and crustaceans, and are capable of pulling them off rocks with their thick lips and sharp teeth.

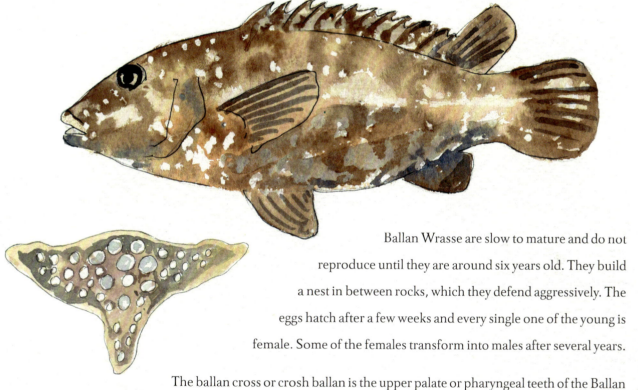

Ballan Wrasse are slow to mature and do not reproduce until they are around six years old. They build a nest in between rocks, which they defend aggressively. The eggs hatch after a few weeks and every single one of the young is female. Some of the females transform into males after several years.

The ballan cross or crosh ballan is the upper palate or pharyngeal teeth of the Ballan Wrasse, loosely thought to resemble a cross. You may have to visit the Isle of Man, where the species is common, to find one of these. The wrasse feeds on mussels and other crustaceans, and uses the ballan cross to crush them.

There are many folklore tales that tell of the power accredited to finding a ballan cross. It will protect you from the Little People; you cannot make a mistake while carrying one; you will never lose your way if you carry one with you. It was probably fishermen who treasured this good-luck charm the most, believing that they would not perish or drown at sea if they carried one.

Autumn

Red Thai curry mussels

I am grateful to Sarah Raven for letting me include this unusual spicy and fragrant recipe for mussels from her book *Food for Friends & Family*. She suggests serving it with coconut and coriander rice to soak up the juice.

Serves 4–6

- 1.5 kg mussels
- 3 tbsp olive oil
- 1 onion, finely chopped
- 1 garlic clove, finely chopped
- 3-cm piece fresh ginger, peeled and finely chopped
- 1 lemongrass stalk, finely sliced
- 2 tbsp red Thai curry paste
- 2 tsp dark brown sugar
- 350 ml fish or vegetable stock
- 100 ml white wine
- 2 tsp fish sauce (optional)
- small bunch of fresh basil or coriander, chopped
- juice of 1 lime

Clean the mussels under cold running water. Discard any broken or cracked ones, and remove the beards.

Heat the oil in a large, flameproof casserole. Add the onion, garlic, ginger and lemongrass, and sauté gently for 3–4 minutes. Add the curry paste, stirring until you can really smell the spices, then stir in the sugar, stock, wine and fish sauce (if using). Bring to the boil.

Reduce the heat to a simmer and add the mussels. Cover the pan with a lid, and cook for 5–6 minutes. Take off the heat and discard any mussels that have not opened.

Stir in all but a tablespoon of the chopped herbs and the lime juice. Scatter a little more of the chopped herbs over the dish.

Pipefish

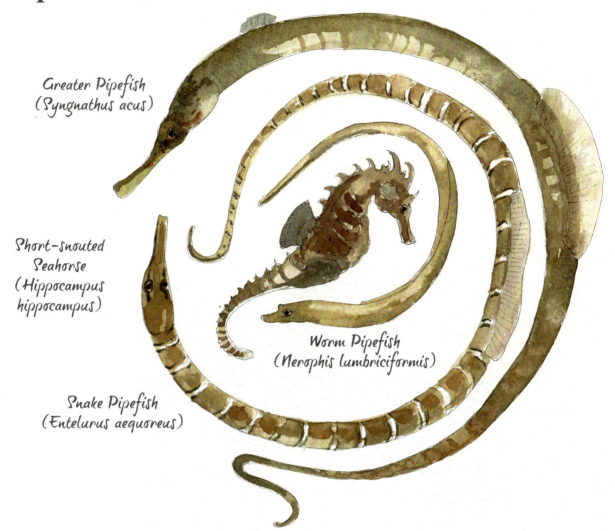

Greater Pipefish (*Syngnathus acus*)

Short-snouted Seahorse (*Hippocampus hippocampus*)

Worm Pipefish (*Nerophis lumbriciformis*)

Snake Pipefish (*Entelurus aequoreus*)

The most remarkable thing about pipefish is their reversed roles in breeding. The female lays her eggs in the male's brood pouch, where he fertilises them and keeps them until they are fully formed. Even once this happens, the young may pop back into the pouch if danger approaches. A female may leave eggs with several males, and in turn the males may brood the eggs of more than one female.

Most pipefish look like snakes and move in a similar way, but they are in fact long, thin seahorses. There are around six species in British waters, the largest of which is the Greater Pipefish, which can be up to 60 cm in length.

Pipefish feed on tiny plankton or fish fry, and do so by sucking their prey into their long, tubular mouth. They have no teeth and their jaws are locked together, but even so they will spit out anything they do not like.

Autumn

How to make a driftwood chandelier

You will need to have a hook fixed to the ceiling beside a light fitting to hang the chandelier from. The chandelier is very simple to make. The difficult part is finding enough long, thin sticks of driftwood – you will need far more of these than you think you do.

YOU WILL NEED:

 large quantity of long, thin driftwood sticks

 water and bleach

 drill with small bit

 reel of thin flower-arranging wire

 1 circular wreath base-wire 45 cm in diameter

 length of string or cord

Soak the driftwood in water with added bleach – this not only kills any bugs that might be lurking, but gives the driftwood a nice pale colour.

Drill a small hole in the top end of each piece of driftwood.

Thread wire through each hole and fix the pieces on the wreath base; you can fix several pieces with the same length of wire. Push them close together. In order to do this it is best to balance the wreath base over a stool or box, so that the fixed driftwood sticks can hang down.

It looks best if you can fix the longest driftwood sticks to the inside ring of the wreath base.

Attach four bits of string or cord at equally spaced intervals to the outside of the wreath base. Make sure they are all the same length, tie them together at the top and hang the chandelier on the hook.

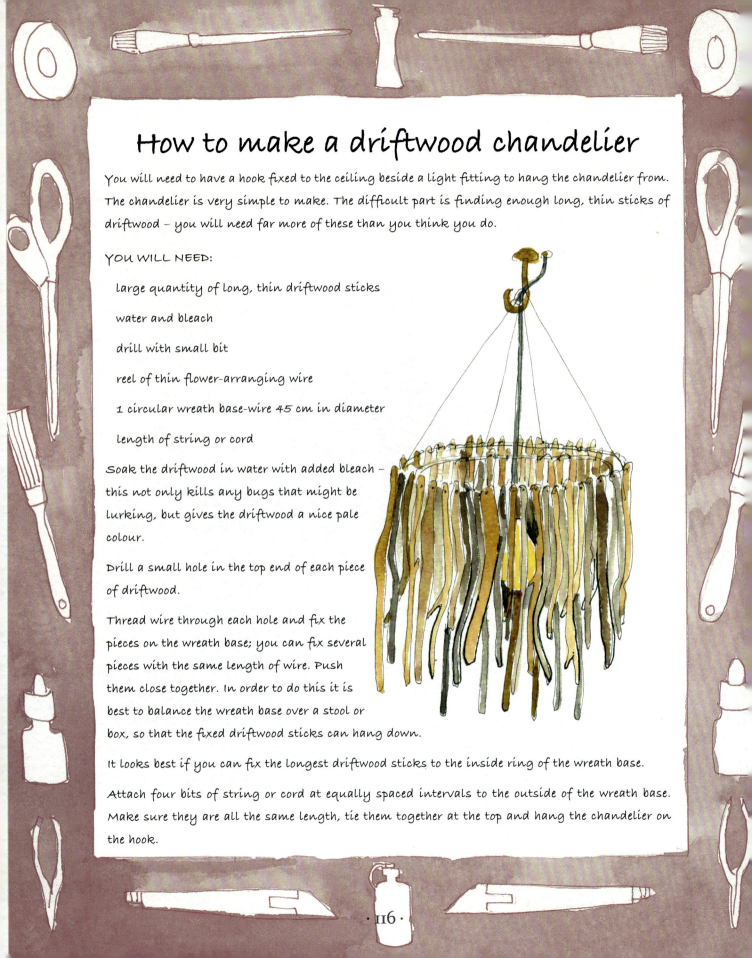

Seaweed tree

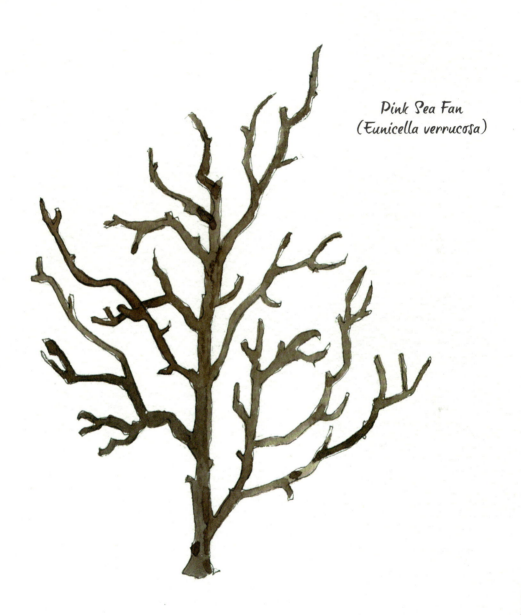

Pink Sea Fan
(*Eunicella verrucosa*)

Seaweed trees are actually **Pink Sea Fans** (*Eunicella verrucosa*) that live in deep water, and while alive are covered in pink, anemone-like polyps. When they die or become unattached they gradually float inshore until they are washed up on beaches. They can be found with only the wood-like core remaining.

Common Lobster

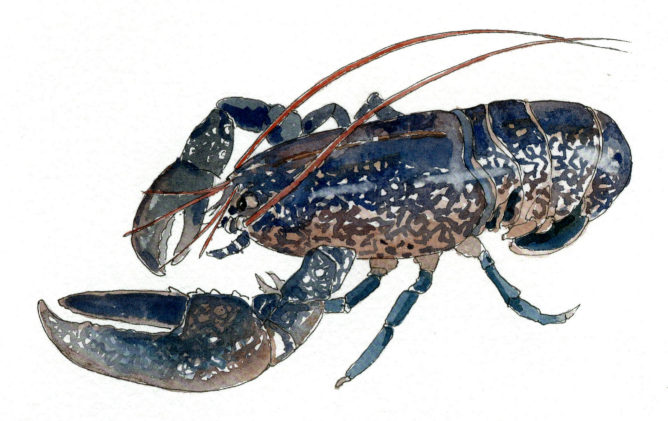

- The Common Lobster (*Homarus gammarus*) is found throughout Europe.
- Prefers to live at a depth of 10–50 m on rocky seabeds.
- Capable of growing to 1 m in length and 7 kg in weight, but most individuals are 30–50 cm in length.
- Possesses eight legs, two claws, prominent eyes and long antennae.
- Claws differ in size, one being used for crushing and gripping, the other for cutting.
- Bluish in colour, turning bright red when cooked.
- Feeds at night, scavenging for anything it can find, including dead fish, starfish and marine worms.
- Breeds year round, the female carrying the eggs on her underside – in this state she is known as 'berried'.
- Caught using a pot or creel.

The dramatic colour change occurring when a lobster is cooked has to do with the way certain biochemicals inside the shellfish react to heat. Lobsters and crabs have a pigment called astaxanthin in their shells. Astaxanthin is a carotenoid pigment, absorbing blue light and appearing red, orange or yellow in colour. While the crustaceans are alive, astaxanthin remains within a protein called crustacyanin. The protein holds the pigment so that its light-absorption properties are changed, and the lobster appears blue-black in colour. Crustacyanin is not stable when heated, so it relaxes its hold on astaxanthin and the natural red colour appears.

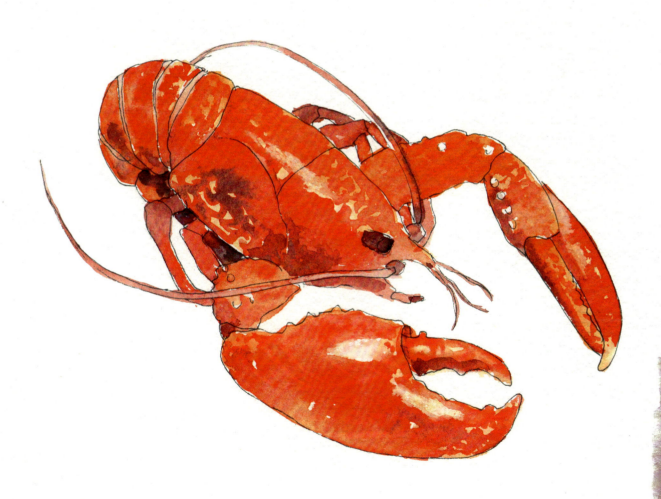

Autumn

Oysters

Two species of oyster are found around the UK: the European Flat Oyster (*Ostrea edulis*) and the Pacific Oyster (*Crassostrea gigas*). The Romans are credited with encouraging Britons to eat oysters; more often than not they were cooked, and perhaps used to stuff chickens. They became so popular that by the mid-19th century as many as 700 million oysters a year were consumed in London alone. By the 20th century overfishing brought the oyster industry to its knees, and in 1965 the Portuguese Oyster (*Crassostrea angulata*) was introduced to try and replenish stocks. Traditionally oysters are eaten when there is an R in the month. Today oysters are considered a luxury – with a reputation for being aphrodisiacal.

How to open an oyster

Opening oysters is tricky, but there is a knack to it. You need an oyster knife, which is a specially designed strong knife. First (if you are right handed) wrap your left hand in a towel or dishcloth, or wear a leather gardening glove; it is easy for the knife to slip and you need to protect your hand.

Hold the oyster with the flat side uppermost.

Tease the knife into the hinge at the pointed end of the shell at an angle.

Twist and slide the knife across the inside of the top shell, which will cut the muscle.

Discard the top shell.

Slide the knife under the oyster to loosen it from the bottom shell.

The oyster is now ready to eat. You can squeeze a little lemon juice onto it, or some people prefer a drop of Tabasco – it is your choice – but then enjoy a true taste of the sea.

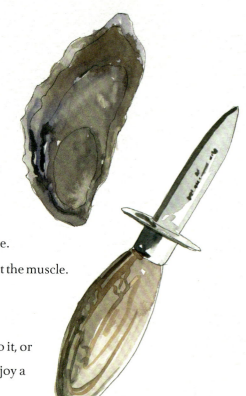

How to make a shell clock

A lot of shell collecting goes into this project, but you will end up with a family heirloom. You can get inset MDF circles from mosaic manufacturers, which have nice neat edges. Battery-operated clock mechanisms are available from craft suppliers.

YOU WILL NEED:

- large number of shells, including 12 mussel shells
- circular piece of MDF or plywood
- battery-operated clock mechanism and hands
- glue gun and glue
- compass

First find the centre of the circle and drill a hole there to fit the clock mechanism at the end.

Measure out and mark the 12 hours, and glue the mussel shells in position.

With the compass draw a few circles on the MDF to keep the pattern of shells regular. Glue on the shells – a quantity of tiny shells will help to fill any gaps.

When the clock face is full of shells, follow the instructions to insert the clock mechanism.

Sea areas and shipping forecasts

Shipping forecasts are issued four times a day by BBC Radio broadcasts produced by the Met Office, and refer to the 31 sea areas shown on the map. The service began in 1861, when Vice-Admiral Robert FitzRoy introduced a warning service for shipping following on from the sinking of the steam clipper Royal Charter in a strong storm in 1859. At first he established 13 instrument stations around the coast. Readings from these stations were telegraphed to London, and gale warnings were issued using a system of cones hoisted at shore stations.

Today's forecast is compiled from information received by radar, satellite and other reporting stations around the coast. It is broadcast in a particular way as the forecast has to be no longer than 350 words.

Here is a typical example: 'Dogger. Southerly 4 increasing 6 to gale 8, veering south-westerly later. Very rough or high. Rain. Moderate or poor.'

Translated, this shows: 'Dogger', the sea area; 'Southerly 4 increasing 6 to gale 8, veering south-westerly later', the wind direction and force; 'Very rough or high', the sea state; 'Rain', the weather; 'Moderate or poor', the visibility.

Or you could just go by these folklore maxims:

If salt is sticky, and gains in weight, it will rain before too late.

Seagull, seagull, sit on the sand, it's never good weather while you're on land.

Wind from the West, fish bite the best.
Wind from the East, fish bite the least.
Wind from the North, do not go forth.
Wind from the South blows bait in their mouth.

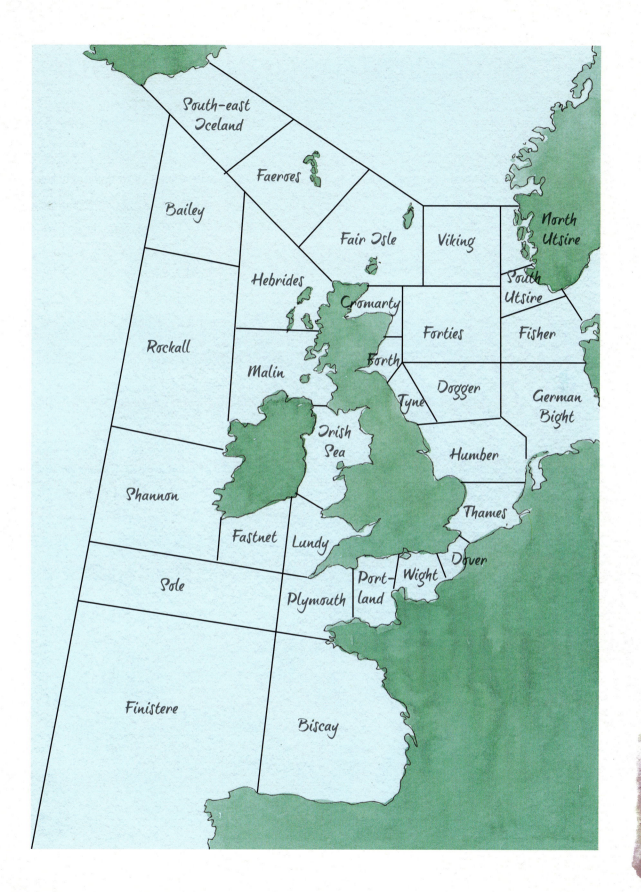

Beaufort Scale

The Beaufort Scale was devised by Sir Francis Beaufort in 1805 to measure wind speed and sea conditions. He standardised conditions so that a so-called 'moderate breeze', for instance, was in fact a wind between 13 and 17 mph rather than simply one person's opinion of the strength.

The scale became standard for Royal Navy vessels in the 1830s.

Wind force	kph	mph	Knots	Wind description	Sea description	Specifications
0	<1	<1	<1	Calm	Calm	Smoke rises vertically
1	1–5	1–3	1–3	Light air	Calm	Smoke drifts
2	6–11	4–7	4–6	Light breeze	Smooth	Wind felt on face; leaves rustle
3	12–19	8–12	7–10	Gentle breeze	Slight	Leaves and small twigs in motion
4	20–28	13–18	11–16	Moderate breeze	Slight–moderate	Raises dust and loose paper
5	29–38	19–14	17–21	Fresh breeze	Moderate	Small trees sway; wavelets form on inland waters
6	38–49	25–31	22–27	Strong breeze	Rough	Large branches in motion; telegraph wires whistle; umbrellas used with difficulty
7	50–61	32–38	28–33	Near gale	Rough–very rough	Whole trees in motion; inconvenience felt when walking into the wind
8	62–74	39–46	34–40	Gale	Very rough–high	Twigs break off trees; progress impeded
9	75–88	47–54	41–47	Severe gale	High	Slight structural damage
10	89–102	55–63	48–55	Storm	Very high	Trees uprooted; structural damage
11	103–117	64–72	56–63	Violent storm	Very high	Widespread damage
12	118+	73+	64+	Hurricane	Phenomenal	Devastation

How to make a fish kite

Children's Day in Japan is on 4 May, and it is traditional for every male in the household to fly a Koinobori kite, which is in the shape of a fish and made of cotton. These kites are simple to make and the process is fun for everyone. For an easy afternoon's entertainment children can make paper kites out of brown paper, crêpe paper or even newspaper – follow the instructions below but use glue instead of sewing. The kites can be hung from trees or used as room decorations, but to fly them they need to be attached to a stick and run with.

YOU WILL NEED:

- bits of old sheet or any light fabric
- fabric or acrylic paint
- pipe cleaner or bendy wire
- strong thread
- stick

First draw a simple fish as long or as short as you like on the fabric, with a straight line at the bottom as shown.

Cut out along the top and fold in half between points A and B.

Trace around the first fish in order to ensure that both halves are exactly the same.

Cut out the second side.

Paint the fish.

Fold in the mouth edge and sew a seam, then insert the pipe cleaner.

With right sides together sew along the top line, leaving the mouth and tail ends open.

Turn inside out so that the drawn sides are on the outside again.

Make three small holes by the mouth and attach a 45-cm length of thread to each hole. Tie the three lengths together and then attach a single thread as long as you wish. The longer it is the faster the kite flier will have to run. Tie the thread to your stick.

Insects found on shores

A large number of insects can be found on British coasts, ranging from beetles, crickets and flies, to moths and butterflies.

Strandline Beetle (*Broscus cephalotes*) A nocturnal ground beetle with a dull black carapace, the Strandline Beetle is found in grassy sand dunes, where it feeds on a wide variety of food. It attacks anything it comes across, including ants and woodlice. The larvae stay in subterranean tunnels, developing over winter, and emerge as adults in spring. Adults tend not to survive the winter.

Beachcomber Beetle (*Nebria complanata*) This rare nocturnal beetle not unsurprisingly lives among the strandline debris, and hunts for sandhoppers and other invertebrates.

Sea Bristletail (*Pterobius maritimus*) Sometimes called the Shore Bristletail, this insect is very common and nocturnal, spending the day hiding in dark places. It is a fast-running creature that feeds on lichen and various micro-organisms.

Kelp fly (*Coelopa frigida*) Also known as seaweed flies, kelp flies such as this species, which has no common name, are found on rotting seaweed all year round, but mainly in autumn. Sometimes there is a mass hatching and the flies migrate inland, causing a nuisance.

Tawny Mining Bee (*Andrena fulva*) This is a common, spring-flying solitary bee that nests in sand, building a little hollow mound around the entrance to its burrow. It flies between April and June. The young develop underground, hibernating as pupae over winter.

Red-banded Sand Wasp (*Ammophila sabulosa*) This charming creature feeds on caterpillars. It stings a caterpillar to paralyse it, then drags it to its nesting hole in the sand. The caterpillar is squeezed into the hole and the wasp lays an egg on it then seals it in, sometimes using a pebble or debris to disguise the hole. The female may dig several nests, provisioning each with one or more caterpillars.

How to fillet a fish

The word fillet comes from the French *filet*, or slice, and this is exactly what you will produce once you have filleted a fish – two boneless slices.

Place the fish on a board and trim off the fins on each side of the head.

With a sharp knife slice along the stomach from the small hole by the tail to the head. Remove the contents of the stomach and rinse the fish under cold water.

Remove the head and gills.

With the tail towards you slice all the way down the spine, easing the knife between the spine and the flesh. Use a slicing movement, not a sawing one, and lift the fillet as you go.

As you reach the ribs, slide the knife over the bones until the fillet comes free.

Repeat with the reverse side – note that you may find this side harder to remove.

Five flatfish

In the early stages of growth a flatfish looks like a conventional fish species, but as it grows its head shape changes so that both its eyes are on top. In some species the eyes are usually on the right side of the body, in others generally on the left side. See also Dover and Lemon Soles (pages 106–107).

From the centre out:

Common Dab (*Limanda limanda*) At up to 45 cm in length, this species is the smallest of the flatfish. It is light brown, has eyes on the right side and its back feels rough. It feeds on marine worms, other fish, brittle stars, small urchins, crustaceans and molluscs. Breeding commences as soon as water temperatures rise in spring. The female lays about 100,000 eggs, which float to the surface and hatch after one week.

European Flounder (*Platichthys flesus*) This mainly mid-brown flatfish is up to 47 cm long. It occasionally interbreeds with the European Plaice, so can have reddish spots. Its eyes are on the right-hand side. The diet consists of cockles, sand hoppers, shrimps, marine worms and molluscs. Adults move to deeper water in spring. The female lays about 1–2 million eggs, which hatch after around two weeks.

European Plaice (*Pleuronectes platessa*) Up to 28 cm in length, European Plaice have bright orange or red spots, and can alter the colour of their backs in order to camouflage themselves. Their eyes are on the right-hand side. They feed on razor shells, cockles, sandeels, brittle stars and marine worms. The adults spawn in January–March in specific spawning grounds. The female lays around 500,000 eggs that float to the surface and hatch after 2–3 weeks.

Brill (*Scophthalmus rhombus*) Up to 90 cm in length, Brill are greenish-brown with spots and speckles. Their eyes are on the left-hand side. Their diet consists of small fish, including sandeels, and large crustaceans. Breeding takes place in spring and summer in shallow water.

Turbot (*Scophthalmus maximus*) This is the largest flatfish, at up to 120 cm in length. It is variable in colour, as it can change to suit its background, and is covered in spots and speckles. The eyes are on the left-hand side. Turbot feed on small fish such as sandeels and herring, crustaceans and molluscs. Breeding occurs in spring and summer. The female can produce up to 15 million eggs.

Autumn

Molly's mackerel bake

This is my grandchildren's favourite lunch. There is no need to weigh things carefully – this is a 'bung-it-all-in' recipe. The basic quantities are 1 mackerel (2 fillets), 1 large potato and 2 shallots per adult, and half of this amount per child.

To serve 2 adults and 2 children

 3 filleted mackerel (6 fillets)
 3 large potatoes, cubed (skin on or off, as preferred)
 2 bay leaves
 6 shallots, sliced
 glug of olive oil
 chopped parsley, to garnish

Preheat the oven to 230º C.

Place the cubed potatoes, bay leaves and shallots in a large, ovenproof dish.

Drizzle some olive oil over these ingredients, and mix well.

Pop the dish in the oven for 40 minutes until the potatoes are soft inside but crispy on top.

Lay the mackerel fillets skin-side up on top of the potatoes, then return the dish to the oven for 10 minutes.

Remove the dish from the oven and peel the skin off the mackerel, using a knife and fork.

Spread out the mackerel over the potato mix, and top with a sprinkle of parsley.

Serve with a green vegetable such as broccoli, or just a simple salad.

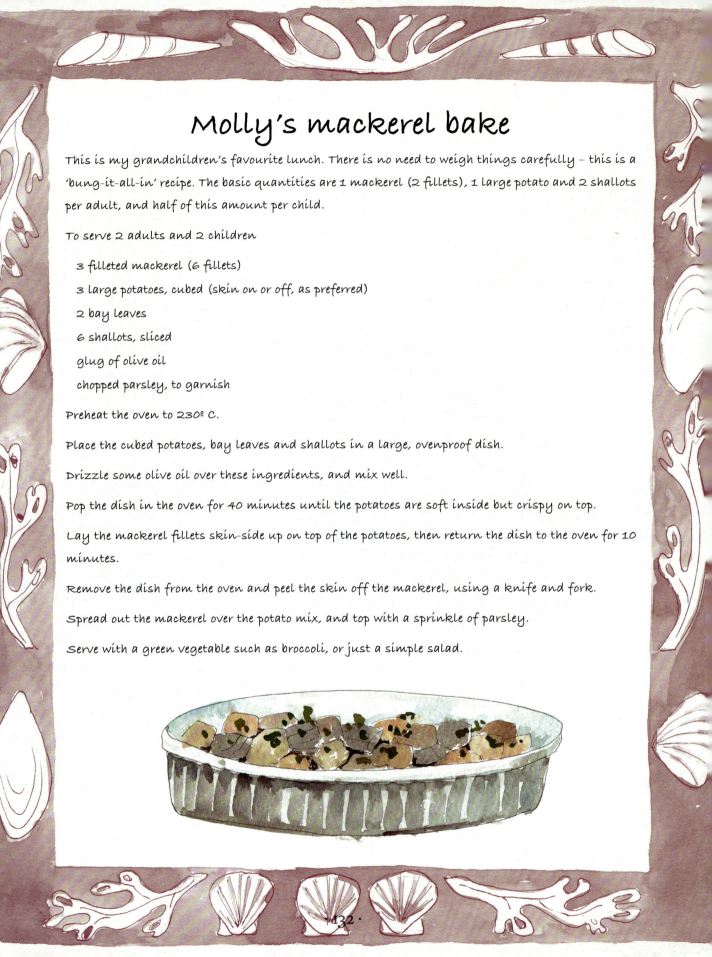

Furbellows and Oarweed

Furbellows (*Saccorhiza polyschides*) can grow to up to 4 m in length. It has a stipe with corrugated edges and a strange knobbly, warty holdfast that sometimes washes up on the strandline by itself. It is very common.

The **Oarweed** (*Laminaria digitata*), or Kelp, is similar to Furbellows. It is 3–4 m in length, but has a smooth, flexible stalk that breaks up into strap-like sections, and a more root-like holdfast. This is also a very common seaweed.

Autumn

Is it a Smew, Scoter or Goldeneye?

Smew

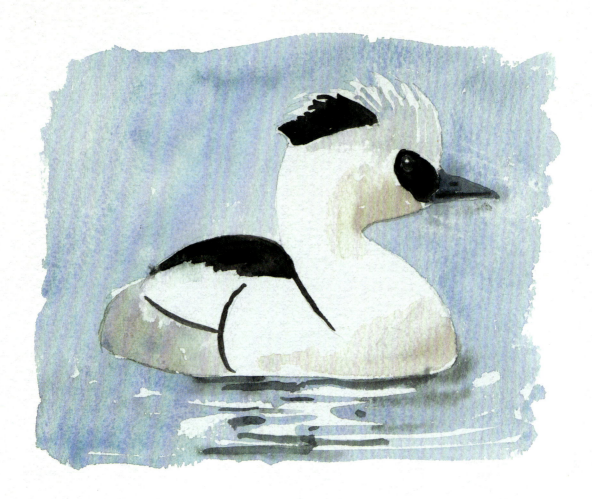

The **Smew** (*Mergus albellus*) is a small, compact diving duck. It feeds on fish, insect larvae and other insects. The male (illustrated here) is white with a black eye-patch and back, and the female is grey with a ruddy head and white cheeks. The species is a winter visitor from Scandanavia and Russia.

Common Scoter

The **Common Scoter** (*Melanitta nigra*) is a diving duck that feeds on molluscs. The male is totally black, and the female (illustrated) is lighter brown. The birds often form large rafts out at sea. Small numbers breed in Scotland, and large numbers arrive from October for the winter, leaving in March.

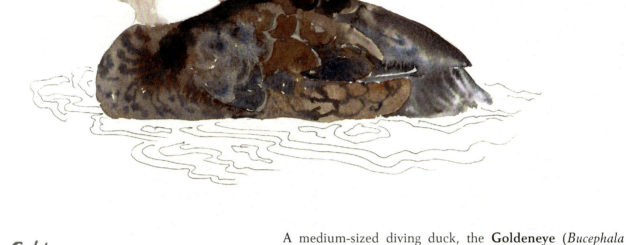

Goldeneye

A medium-sized diving duck, the **Goldeneye** (*Bucephala clangula*) feeds on mussels, insect larvae, small fish and plants. The male (illustrated) appears black and white but has a greenish head. Females are mottled grey and brown. Both sexes have striking golden eyes. The birds breed in Scotland, and overwintering birds arrive from August and leave in February.

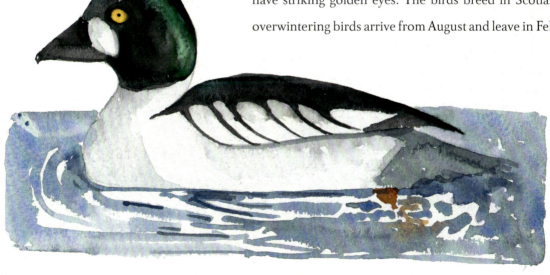

Autumn

European Otter

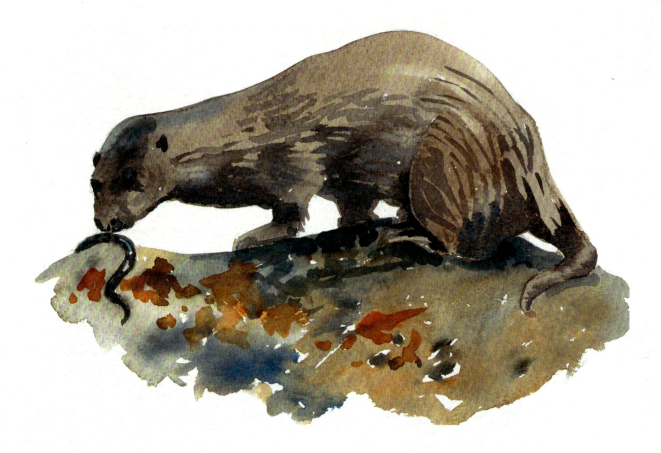

- The European Otter (*Lutra lutra*) belongs to the family Mustelidae, which includes Badgers, Weasels, Stoats and Pine Martens.
- Lives by water and is as happy in coastal areas with salt water as it is around lakes and rives.
- Small ears, round eyes and a flattish head.
- Ears and nostrils can close when underwater, and webbed feet ensure that otters are strong swimmers.
- Naturally shy, but unmistakable when moving on land due to their lolloping gait.
- Once in the water swims close to the surface with just the head and back showing until it dives, when the whole tail is visible looping over as the otter disappears.
- Staple diet is fish, particularly eels, and crustaceans, but being carnivores otters eat anything they can catch, including birds and small mammals.

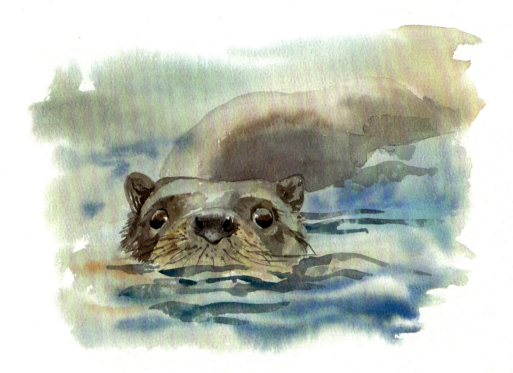

- Agile swimmer capable of slowing the heart rate to reduce oxygen consumption underwater.
- Long whiskers so sensitive that they can detect the approach of a fish.
- Males (dogs) and females (bitches) reach breeding age at two years, and although there is no specific breeding season, spring is the most likely time for them to produce litters.
- Mating takes place in the water, and each litter consists of 1–2 cubs, which are born blind in a burrow known as a holt.
- No predators apart from humans, but due to loss of habitat otters are more scarce than they once were.

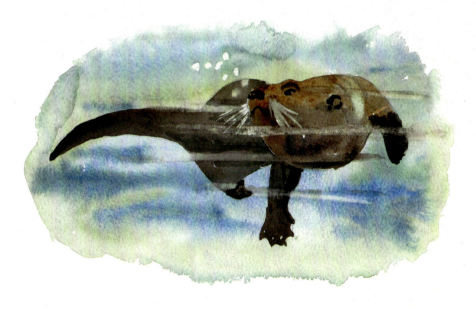

Autumn

Chough

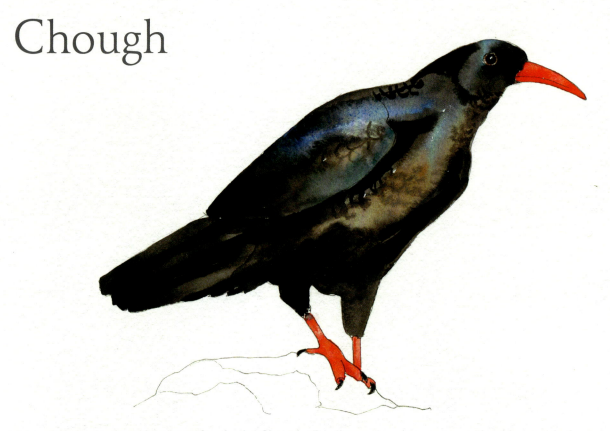

A handsome member of the crow family, the Chough (*Pyrrhocorax pyrrhocorax*) is easily recognisable due to its red legs and bill. It is sometimes called the Cornish Chough because according to Cornish legend it is said that King Arthur was transformed into a Chough when he died, the red feet and beak representing his violent end. One of 18 verses of R. S. Hawkder's 'The Wreck' (1846) reads:

> And mark yon bird of sable wing,
>
> Talons and beak all red with blood;
>
> The spirit of the long-lost king
>
> Passed in that shape from Camlan's flood

So important is this bird to Cornwall that it appears on the county's coat of arms. Having become extinct in the UK in the early 20th century, the Chough returned to Cornwall in 2001. Today it is found in small numbers all around the west coast of Britain and Ireland.

Rock faces are the species' preferred nesting site, but birds may also use buildings for their untidy nest piles made of twigs, roots and moss. Apart from during the breeding season, when pairs are monogamous, the birds are sociable and live in flocks of up to 30, roosting communally.

Sea buckthorn jelly

Sea buckthorns are attractive low-growing bushes with greyish leaves and bright orange berries. They make an unusual and beautifully coloured jelly that can be used in place of redcurrant. The addition of a few cooking or crab apples enhances the flavour (and saves picking time!)

Makes about 8–10 x 250 g jars

1½ kg sea buckthorn berries

4 cooking apples or 8 crab apples, roughly chopped

500 ml water

100 g jam sugar per 100 ml liquid

Wash the berries and place them with the apples directly in a heavy-based saucepan, along with the water.

Bring to a boil, reduce to a simmer and cook for 30 minutes, mashing the fruit with a wooden spoon or potato masher.

Pour the fruit pulp into a jelly bag lined with several layers of muslin, and allow to drain into a bowl (do not be tempted to squeeze the bag as this will only make the jelly cloudy).

Leave overnight.

The following morning measure the volume of the liquid and add 100 g sugar per 100 ml of fluid.

Place the juice and sugar in a saucepan, heat through, then add the sugar, stirring until completely dissolved.

Bring to a boil and cook rapidly for about 15 minutes. Test for setting by cooling a plate in the refrigerator, then spooning a little of the jelly onto the plate. Allow to cool for a second or two, then push the jelly with your finger. If a crinkly skin forms the jelly is ready. If not continue boiling for 5 minutes more and test again.

Skim the surface, then ladle the jelly into sterilised jars that have been warmed in an oven for 5 minutes.

Cover the jars and label them.

Is it a Rock Pipit or a Meadow Pipit?

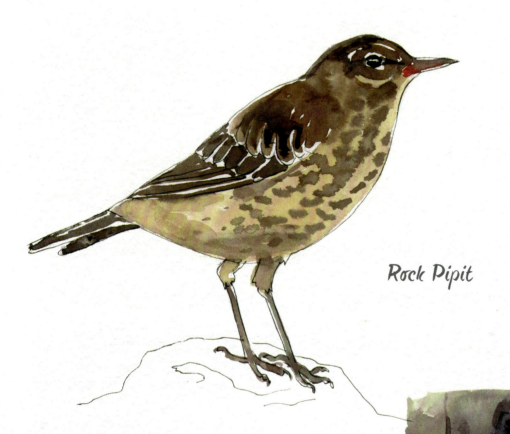

Rock Pipit

The **Rock Pipit** (*Anthus petrosus*) is 16 cm long and has a wingspan of 25 cm. The grey feathers in its tail differ from those of all other pipits, and it has dark legs and is larger and darker than the Meadow Pipit. The species lives and breeds on open grassland and dunes, feeding on the tide line on small marine shrimps and molluscs. Its nest is constructed in a recess on a cliff or bank, and is a cup of plant stems with a finer lining of fibres or hair. The female lays 4–6 whitish-grey eggs that are heavily spotted with brown and pale grey. Incubation takes 14–15 days.

The **Meadow Pipit** (*Anthus pratensis*) is 14 cm long, with a wingspan of 24 cm. Smaller and paler than the Rock Pipit, it has white outer-tail feathers, pale pinkish legs and a pale bill. It lives on rocky coasts, but may frequent mud and estuaries in winter. The birds feed on insects and seeds in winter, nearly always on the ground. They nest on the ground, with the nest being a large cup of dry grass and moss with finer lining. The female lays 4–5 eggs (sometimes as many as seven), which are variable in colour.

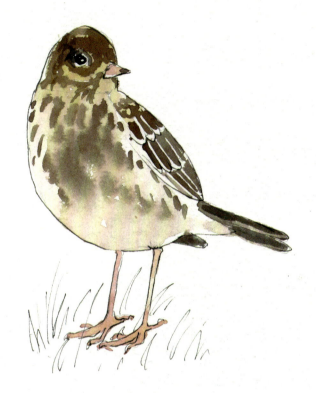

Meadow Pipit

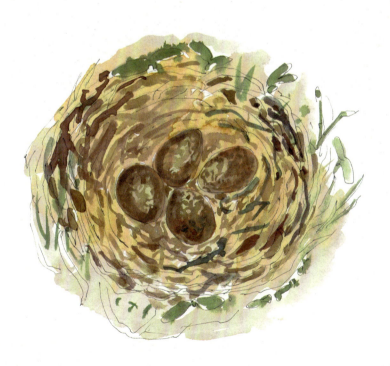

Autumn

· 143 ·

How to make a hobby seahorse

YOU WILL NEED:

1 broom handle

1 30-cm piece of 2-cm dowling

thick paper

large piece of green felt

small piece of pale green felt

2 large buttons

stuffing (for example old socks, tights, moth-eaten sweater)

drill with 2-cm bit

needle and thread

Drill a hole in the broom handle approximately 30 cm from the top, and insert the piece of dowling.

Use the thick paper to make templates for the seahorse head. Enlarge the templates to the size you want (my seahorse head measured 30 cm from the end of the nose to the back of the head).

Using your templates, cut out two pieces of A in dark green felt, one piece of B in pale green felt and two pieces of C in pale green felt.

Sew the buttons into position as eyes, one on each side of the head. (You could use two circles of pale green felt instead if you do not have buttons).

Sew on the two cut-out pieces of pale green felt (C) on either side of the head near the eyes.

Slot the piece for the mane (B) into position between the two main head pieces.

Using blanket stitch (or machine stitching if you prefer), stitch around the head to the back of the cheek (turn it inside out if you like but felt does not fray and I like the look of the seam on the outside), and stuff the nose at this point.

Continue stitching but leave the neck open. Insert the broom handle and put stuffing all around it so that it remains in the middle. Sew up the neck.

Winter

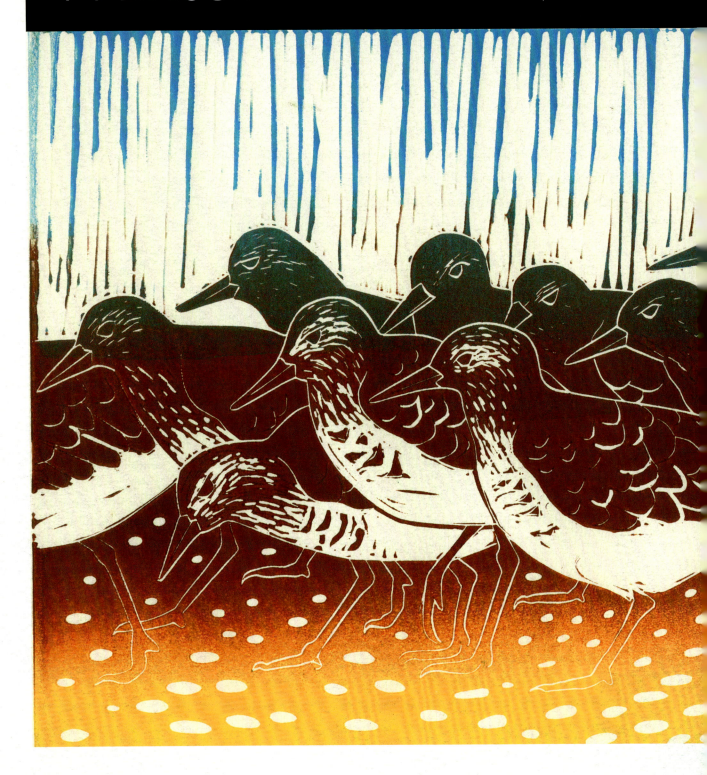

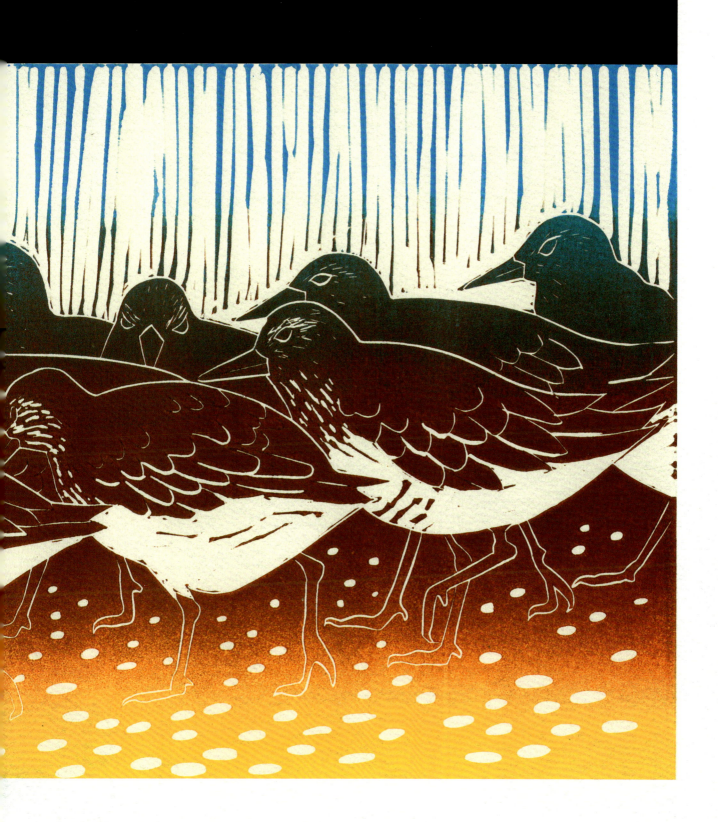

Black-headed Gull

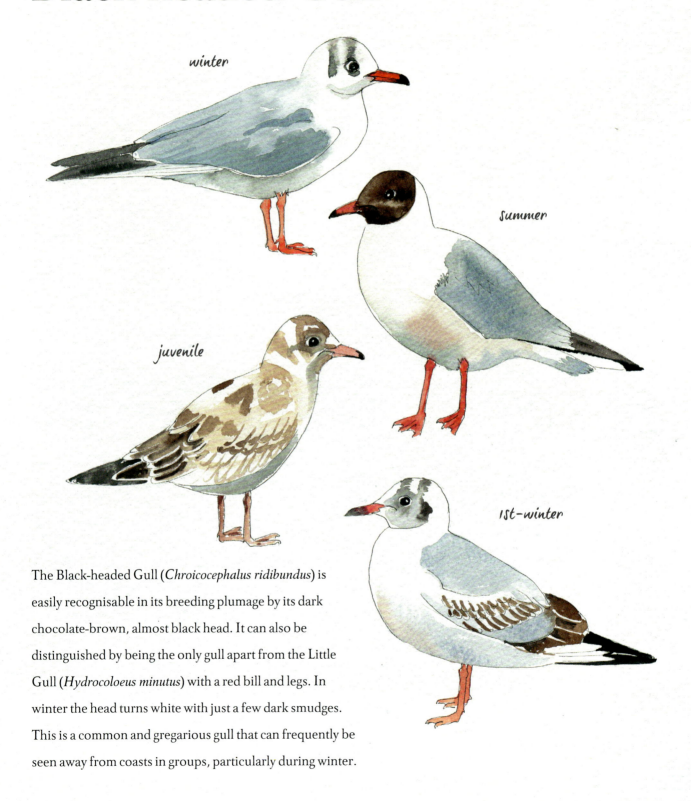

The Black-headed Gull (*Chroicocephalus ridibundus*) is easily recognisable in its breeding plumage by its dark chocolate-brown, almost black head. It can also be distinguished by being the only gull apart from the Little Gull (*Hydrocoloeus minutus*) with a red bill and legs. In winter the head turns white with just a few dark smudges. This is a common and gregarious gull that can frequently be seen away from coasts in groups, particularly during winter.

Common Piddock

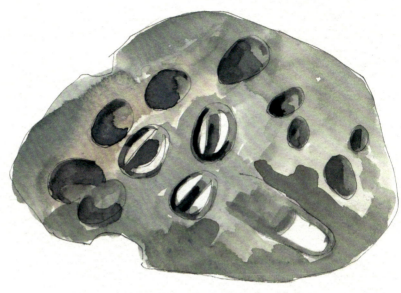

Have you ever seen rocks or lumps of driftwood with holes bored into them and wondered what caused them? These holes are the work of the Common Piddock (*Pholas dactylus*), a bivalve that, at one end of its shell, possesses strong teeth-like protuberances that are capable of boring into rock. The piddocks live in the holes they have bored, from where they extend a siphon through which they filter food from the water. A second syphon empties their waste back into the sea.

As it grows (up to 12 cm long) the piddock is continually chiseling away at its burrow to enlarge it. This common shell is rarely found on the beach because they are remarkably brittle and break up easily.

The Common Piddock, like members of its genus *Pholas,* are phosphorescent and glow with a greenish light in their burrows. Apparently if you chew one up and keep it in your mouth your breath will become luminous – sadly, I haven't had the opportunity to check whether this is true!

Winter

Dublin Bay Prawn

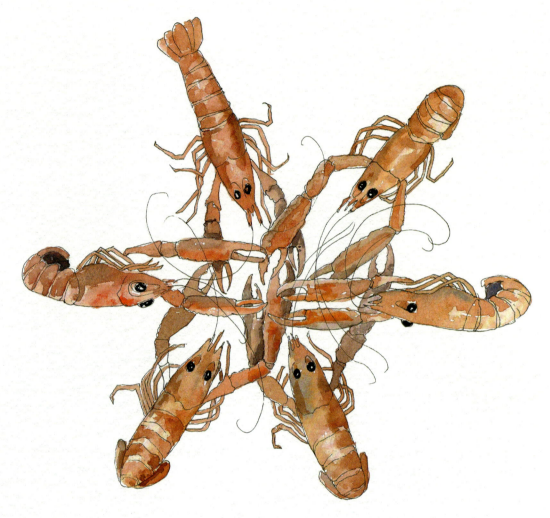

- The Dublin Bay Prawn (*Nephrops norvegicus*) is also known as the Langoustine, Scampi and Norway Lobster.

- Reddish relative of the Common Lobster (see page 118).

- Lives in burrows on the seabed, requiring muddy silt to excavate its burrows.

- Females can live for up to 20 years, maturing at three years.

- In the autumn lays eggs that remain attached to tail for nine months (know as being 'berried'); stays in burrow during this time and therefore escapes being caught by trawls.

- Eggs hatch in spring and females emerge to moult and mate.

- Mainly caught by trawlers using otter boards, but can also be trapped in baited pots or creels.

Kipper pâté and Melba toast

This was all the rage in the 1970s, when food was plainer and people were more frugal. Back then you could buy boil-in-the-bag kipper fillets, but the flavour of this pâté is greatly enhanced if you use a properly smoked kipper. Here is how to make one kipper feed four as a first course. You could exchange the full-fat cheese for crème fraîche if you prefer, and play about with chilli sauce – just a little something hot gives the pâté a bite.

Serves 4

- 1 large kipper
- juice of 1 lemon
- 75 g full-fat cream cheese
- 1 tsp horseradish
- 1 splash of Tabasco or similar
- handful of chopped parsley
- pinch of nutmeg
- grind or three of black pepper

Place the kipper in a bowl and cover with boiling water. Leave for 10 minutes.

Very carefully remove all the flesh from the kipper, leaving the skin and bones.

Place the kipper in a liquidiser with the lemon juice, cream cheese, horseradish, Tabasco, chopped parsley, nutmeg and black pepper. Whizz until a smooth paste is formed.

Place in a suitable container and refrigerate. The pâté will keep for several days.

You can serve the pâté with crusty bread, but I think it goes best with fairy (or Melba) toast. This is easy to make once you have worked out how long to leave it in the oven. It stays crisp for days, so can be made in advance.

To make the toast you need thick sliced bread. Toast it as normal, cut off the crusts, then with a broad, flat knife slice right through between the toasted sides. Scrape off any doughy bits from the untoasted side, place on a baking tray in batches and put in a preheated 230º C oven. Depending on how hot the oven is, it will only take 3–5 minutes for the bread to crispen and curl up.

Beachcombed feathers

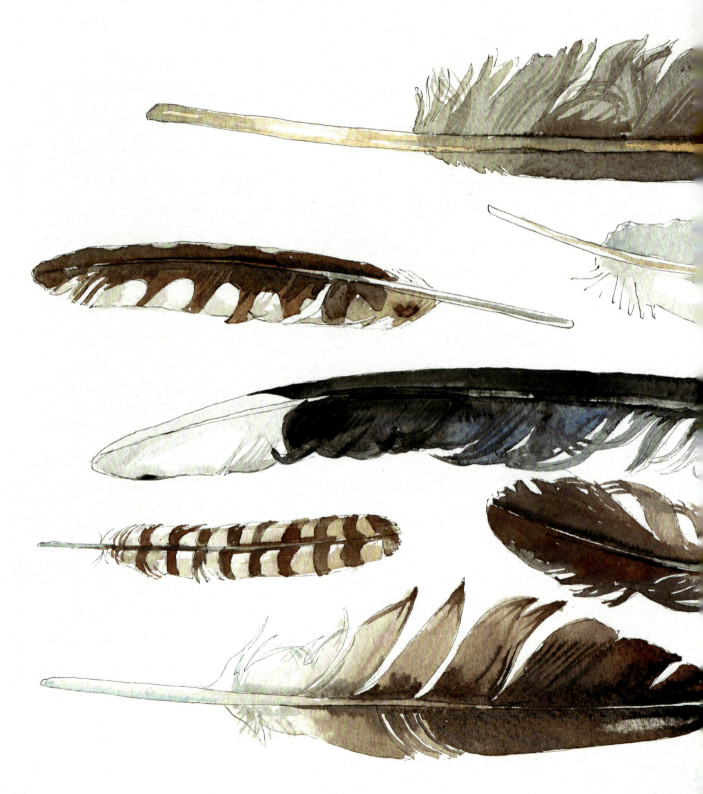

A walk along a beach will reveal a wealth of feathers from assorted seabirds. Those illustrated here are from seagulls; the striped ones are possibly from Knots or Redshanks.

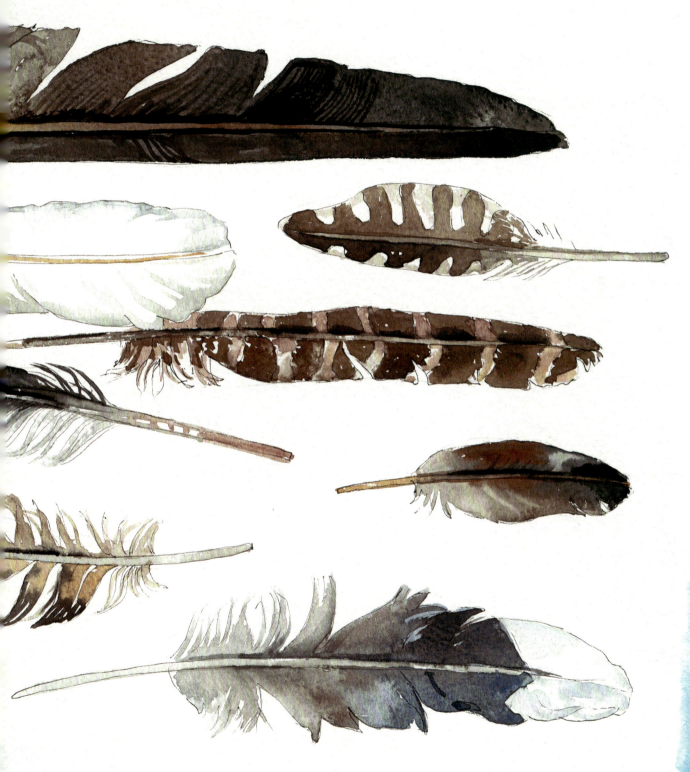

Winter

How to make a driftwood Christmas tree

This tree is not just for Christmas, but will look good at any time of year. When Christmas comes around decorate it with traditional Christmas decorations and fairy lights, or make your own by painting shells gold and silver.

YOU WILL NEED:

 large lump of driftwood or log for base

 1 tall, sturdy driftwood piece for the trunk

 quantity of straight driftwood of different lengths

 beading or any bendy fine wire

 drill with small bit

Make a hole in the log base large enough to take the driftwood trunk and insert this (a drop of glue in the base will ensure that the tree is robust).

Grade the pieces of straight driftwood from long to short.

Drill a hole through the middle of each driftwood piece.

Starting at the bottom, wire the longest driftwood piece onto the trunk, and continue doing this with the other driftwood pieces, ending up with the shortest ones at the top.

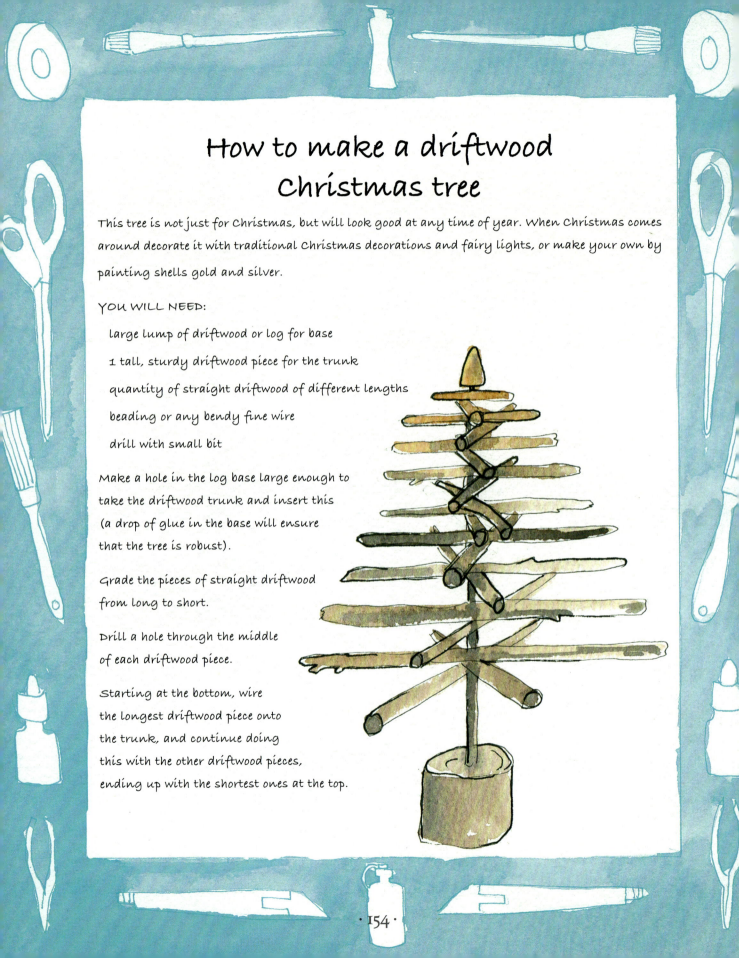

Bones and bone-like objects

All sorts of fascinating things wash up and can be found on the strandline and high-tide line if you keep your eyes open, among which are various bones and bony objects. It is fun to try and work out what they are or were. Objects you might find include:

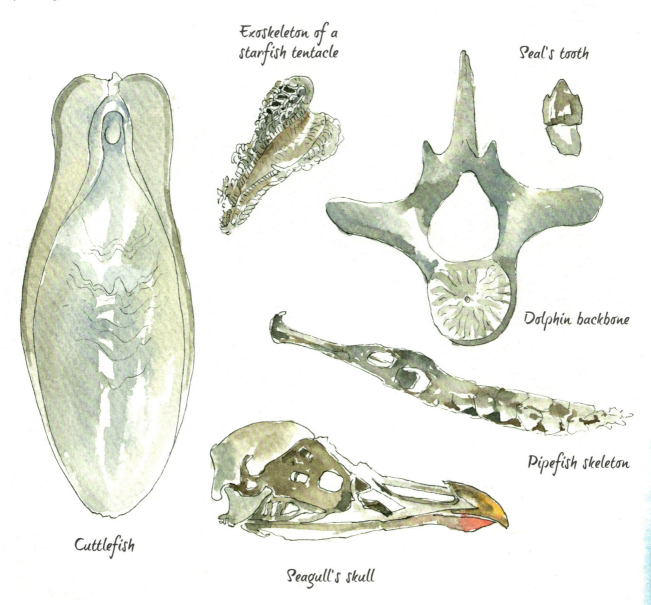

Wracks

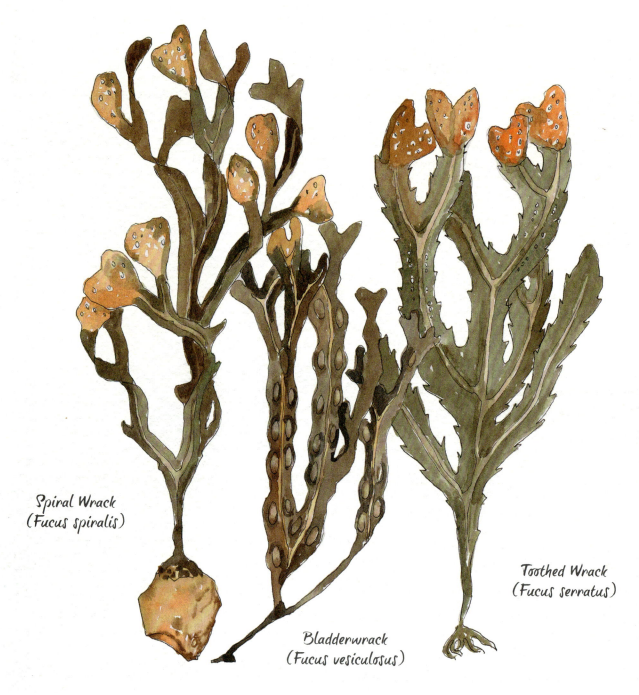

Spiral Wrack
(Fucus spiralis)

Bladderwrack
(Fucus vesiculosus)

Toothed Wrack
(Fucus serratus)

Wracks can be found on almost any rocky shore and are characterised by their leathery and sometimes gelatinous fronds. Some possess bladders that cause the fronds to float up towards the light. Wracks are dichotomous which means that, as the plant grows, wherever it divides it will produce two equal branches.

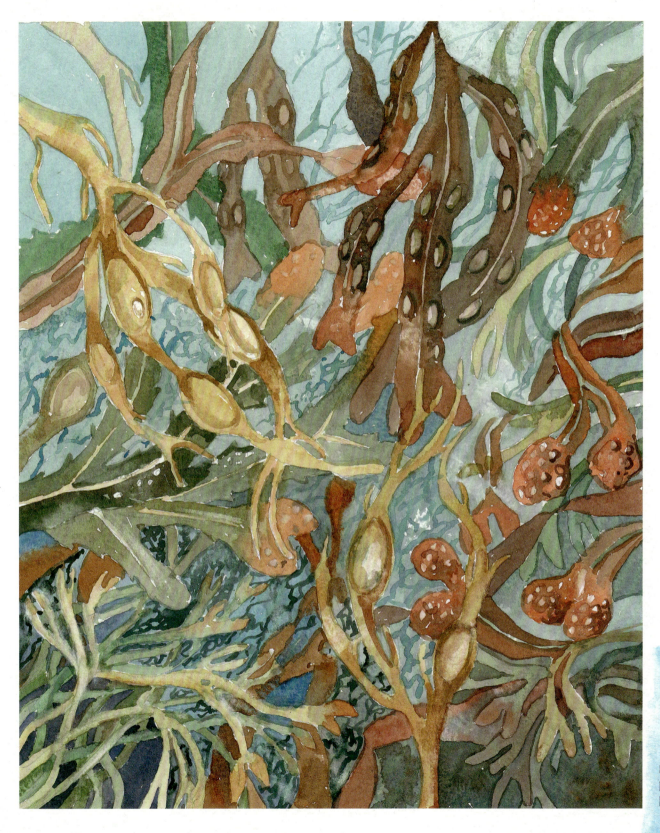

Winter

How to make slate dominoes

Some beaches have slate cliffs, and below them the entire beach will be made up of smooth-edged, flat bits of slate of varying sizes. A set of dominoes is made up of 28 pieces, so you will need 28 oblong bits; do not worry if they are not identical.

YOU WILL NEED:

 28 bits of slate, each approximately 6–8 cm long

 white acrylic paint

Paint the spots on the pieces of slate – some will be blank and each number will have a double. Dominoes are made up as follows (0 = blank):

0:0 - 0:6 = 7

1:1 - 1:6 = 6

2:2 - 2:6 = 5

3:3 - 3:6 = 4

4:4 - 4:6 = 3

5:5 - 5:6 = 2

6:6 - 6:6 = 1

7 + 6 + 5 + 4 + 3 + 2 + 1 = 28

Basking Shark

Although they look like monsters of the deep, Basking Sharks (*Cetorhinus maximus*) are in fact harmless, plankton-feeding fish. They are the largest fish in European waters and the second largest in the world, only being out-sized by Whale Sharks (*Rhincodon typus*). Adults can reach an amazing 12 m in length and live for at least 50 years.

Basking Sharks were hunted almost to extinction for their oil, meat and fins until the mid-1990s. In 1998 they received protection in the UK from the Wildlife and Countryside Act (1981).

Basking Sharks are what is known as ovo-viparous, whereby the female produces eggs that she retains within her body until they hatch, then gives birth to them. They are also oophagous – meaning that they have a clever way of nourishing their young by producing extra infertile eggs for them to feed on.

Winter

Is it a Cormorant or a Shag?

The Cormorant (*Phalacrocorax carbo*) and Shag (*Phalacrocorax aristotelis*) are actually two different birds, although they are similar in many ways – in particular their habit of standing with wings outstretched to dry them after diving for fish, as their plumage is not waterproof.

The Cormorant has dark blue-black plumage with a distinct white patch on its face and also, during the summer months, its thigh. The juveniles are brownish with white underparts.

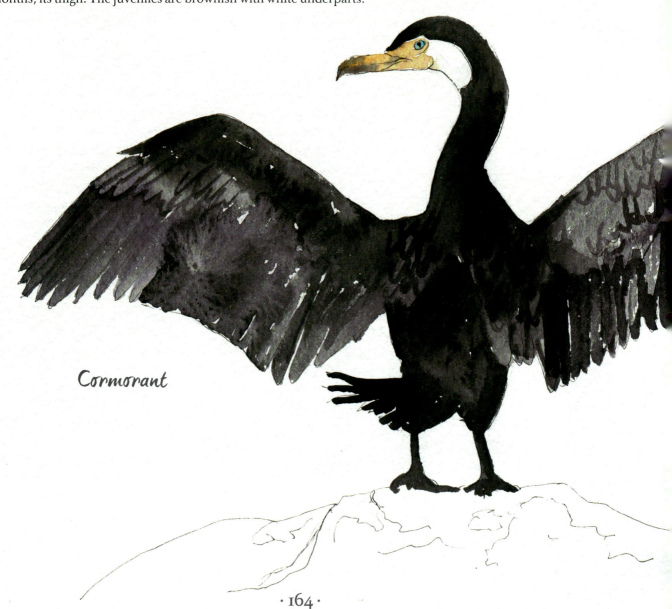

Cormorant

The Shag appears black but is in fact dark green with a small crest on its head. It is smaller than the Cormorant and does not have the telltale white chin-patch. The name Shag is an old word meaning matted hair or wool, and refers to the bird's rather untidy crest.

Both species breed in colonies on sea cliffs.

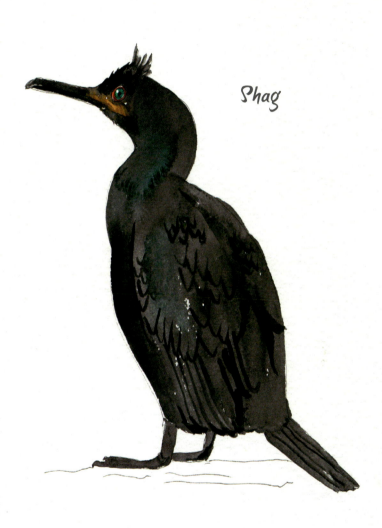

Shag

Winter

Pan-fried cod, chips and tartare sauce

I am very grateful to food writer and chef Katriona MacGregor for allowing me to include one of her 'Speedy Weeknight Suppers' from the *Telegraph*. Served with herby tartare sauce, this is a lighter version of traditional fish and chips that is surprisingly quick to make. Floured and gently pan fried, the cod in the recipe is lighter and less greasy than traditional battered cod. Making your own chips and tartare sauce is quicker than you think, and the result is an altogether fresher meal than a ready-made one.

Serves 2

 2 x 160 g fillets cod (or other firm white fish)

 4 large floury potatoes (Maris Piper or Desiree ideally), peeled and cut into chip-shaped
 batons about ½-cm thick

 1 tbsp sunflower oil

 1 egg

 50–75 g flour

 25 g butter

 salt and pepper

 lemon wedges, to serve

For the tartare sauce

 2 egg yolks

 ½ tsp Dijon mustard

 250 ml rapeseed oil

 1 tbsp natural yoghurt

 squeeze of lemon juice

 1 tbsp capers, finely chopped

 1 tbsp gherkins, finely chopped

 small handful of chopped parsley and dill

 salt and pepper

Preheat the oven to 210º C.

Start off by making the chips. Toss the potatoes in the sunflower oil with salt and pepper in a large oven tray, spreading them out over the base. Place in the centre of the oven for 30 minutes, checking and tossing every ten minutes. If they look as though they are cooking too quickly at the edges, turn down the oven slightly.

While the chips are cooking, make the tartare sauce. Drop the egg yolks into a small bowl with the mustard and a grinding of salt and pepper. While whisking, slowly drizzle the rapeseed oil into the bowl until all of the oil has been incorporated, leaving a thick mayonnaise. Stir in the yoghurt and lemon juice, then the capers, gherkins, parsley and dill. Taste and add a little more lemon, salt or pepper if needed.

About five minutes before the chips are ready, cook the fish. Beat the egg in a shallow bowl and dust the flour over a flat plate. One at a time, drop each fish fillet into the flour, turning it over to completely coat it and shaking off any excess flour. Dip into the egg, letting any excess egg drop off, and lastly dust in a second layer of flour.

Heat the butter and a couple of glugs of sunflower oil in a frying pan until sizzling. Drop in the fish fillets and fry until golden on each side.

Serve with the chips, tartare sauce and lemon wedges.

Weird and wonderful gastropods

Sea slugs and sea hares are molluscs without protective shells. Instead, their bodies are protected by pungent secretions and striking colours that advertise to potential predators the fact that they taste bad. They move with the aid of a muscular foot.

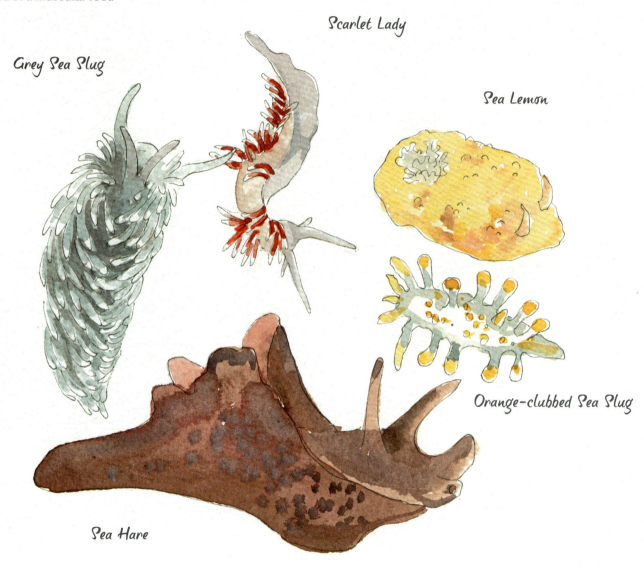

Grey Sea Slug

Scarlet Lady

Sea Lemon

Orange-clubbed Sea Slug

Sea Hare

Grey Sea Slug (*Aeolidia papillosa*) This creature lives on rocky shores where it finds its staple diet of anemones. It is around 12 cm in length and covered in tentacle-like structures called cerata that have white tips.

Scarlet Lady (*Coryphella browni*) A delightfully named nudibranch (or slug) gastropod, the Scarlet Lady grows to up to 3 cm in length and is capable of recycling the stinging cells of the anemones it feeds on into its own red tentacles.

Sea Lemon (*Archidoris pseudoargus*) Measuring 10–12 cm, the Sea Lemon is the most commonly found slug and if you find one you will understand how it was named. It lurks under boulders at low tide and possesses a ring of feathery gills on its rear end.

Orange-clubbed Sea Slug (*Limacia clavigera*) This sea slug only grows to 15 mm. It is found on rocky shores at low tide and may be seen in rockpools.

Sea Hare (*Aplysia punctata*) Someone with a fairly vivid imagination named this mollusc the Sea Hare, supposedly because the front two of its four tentacles (known as rhinophores) resemble hare's ears. The creature is usually around 7 cm in length, but can grow much longer and is capable of producing a cloud of sulphuric acid to deter predators. The body possesses undulating, wing-like sides and has a shell hidden inside. Sea Hares are hermaphrodites and although they mate in pairs, the one in front acting as a female and the one behind as a male, they sometimes form chains with those in the middle being both male and female.

Solar-powered Sea Slug (*Elysia viridis*) This rather lovely sea slug lives and feeds amongst green seaweeds where it is well camouflaged. It is barely 35 mm long and has microscopic blue and red spots, and can be found on northern and south-western coasts of Britain.

Solar-powered Sea Slug

Bivalves

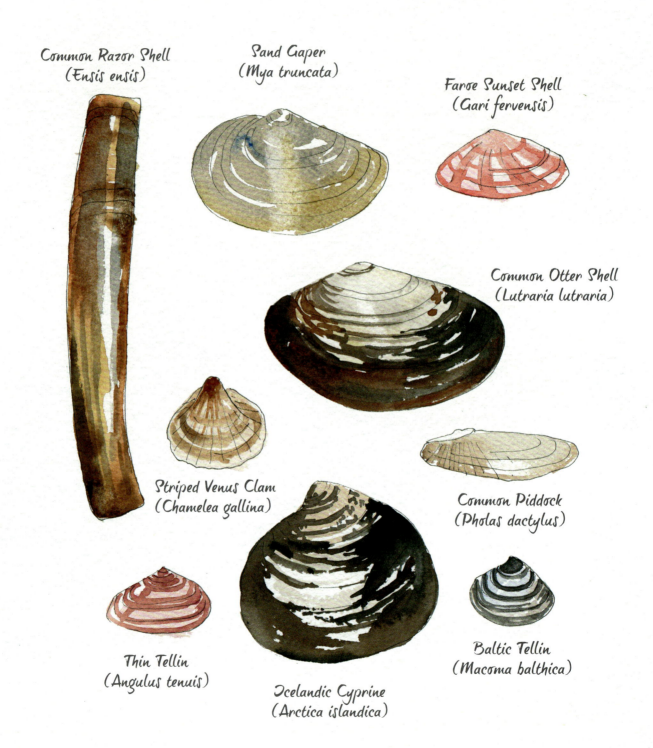

· 170 ·

Worms

Sea Mouse (*Aphrodita aculeata*) Although its resemblance to a mouse is a little tenuous, the Sea Mouse is in fact a worm in the same phylum (or taxonomic group) as an earthworm. It is covered all over in greyish-brown bristles with finer iridescent ones along its sides. It lives buried head first in muddy sand below the high-tide line. No head is visible but two horn-like palps protrude in the front of the body which may reach up to 20 cm in length.

Beauty is in the eye of the beholder it is said and this worm is named after the Greek goddess of love – you can judge for yourself if you are lucky enough to find one washed up on the beach.

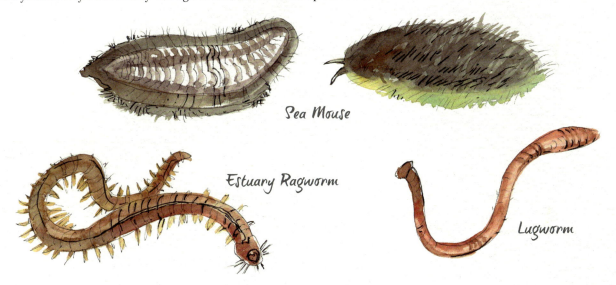

Sea Mouse

Estuary Ragworm

Lugworm

Estuary Ragworm (*Hediste diversicolor*) Prized by fishermen as bait, this is a rather flattened worm, reddish to begin with but turning greener as it matures. Growing to a length of around 12 cm, the body is made up of 120 segments, with 2 antennae, 2 palps, 4 tentacles and 2 tail appendages. These worms are omnivorous feeding on anything and everything they come across. They live in burrows in muddy sand but can sometimes be found under stones.

Lugworm (*Arenicola marina*) Like the Ragworm, though slightly smaller, the Lugworm is also used as bait by fishermen. They dig them up from beaches by looking for their telltale cast next to their burrows, which are shallow and U-shaped. They feed on any organic particles that happen to fall into their burrows, filtering the nutrients before excreting any undigestible parts as a cast on the sand's surface.

Winter

European Sea Bass

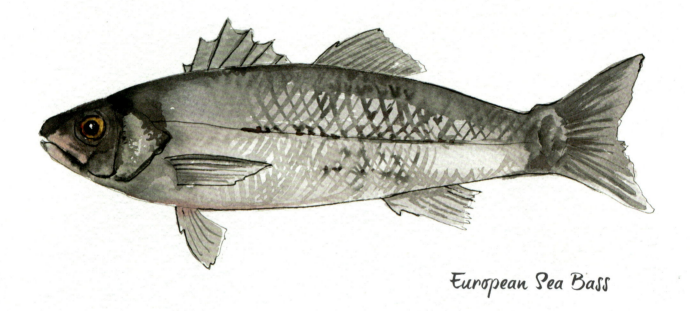

European Sea Bass

The European Sea Bass (*Dicentrarchus labrax*) is a popular sportsfish that can often be found close inshore and can grow to up to 1 m in length. Spawning takes place between February and April in deep water, and the eggs drift on currents before hatching into planktonic larvae. The baby fish seem to favour estuaries and can often be found in large shoals.

Once the fish reach around 35 cm (males) and 42 cm (females) they mature, then begin an annual migration from feeding ground to spawning ground. They can grow to 9 kg in weight, and live for an amazing 30 years. Their prey includes crabs, shrimps and other fish such as sandeels and sprats.

How to make a beachcombed wreath

YOU WILL NEED:

metal wreath ring

flower-arranging or beading wire

whatever you can pick up on a beach (see below)

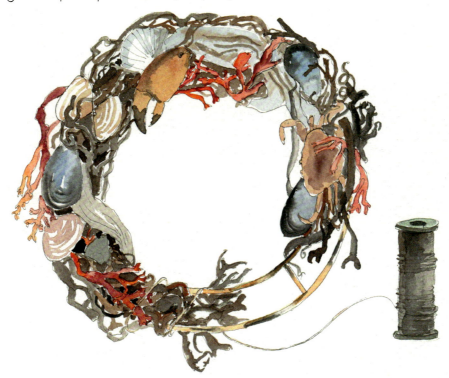

Build up your collection of beachcombed treasures – any broken shells, moulted crab shells, pebbles with holes, seaweed that has been washed up or even feathers.

Collect plenty of seaweed – any type will do – to create a base for the wreath. It is best to rinse the seaweed, then let it dry out. Some seaweed, such as Irish moss or Carrageen, retains its beautiful red colour.

Start by wiring the seaweed onto the ring, then add the bits and pieces. You can glue them on or tuck them in, or to be really neat drill small holes and wire them invisibly to the ring.

Baked Sea-bream à la Veracruzana

Many thanks to Thomasina Miers for allowing me to include this recipe from her book *Wahaca: Mexican Food at Home*. Thomasina says: 'This is a beautifully simple recipe that you can put together at the weekend for friends or family, and that tastes so good it will be long remembered. In fact it has now become a staple recipe when I am entertaining: the smoky mescal (a drink like tequila), sweet tomatoes and light spice of the jalapeño chillies make a really spectacular marriage of flavours.' Thomasina states that this dish is delicious with very simply cooked long-grain rice.

Serves 4–6

1 or more sea-bream, 1.4 kg in total, gutted and descaled

sprigs of thyme

50 g butter

150 ml dry white wine

150 ml mescal or reposado tequila

4 tbsp extra-virgin olive oil

2 onions, finely chopped

4 garlic cloves, sliced

2–3 bay leaves

½ tsp ground allspice

sprigs of marjoram, roughly chopped

2 tbsp small capers

50 g pickled jalapeño chillies

2 x 400 g tins plum tomatoes

Preheat the oven to 200º C.

Wash the sea-bream inside and out and pat dry. Fold a large piece of foil in half to make a generous double-layered wrapping for the fish inside a baking tray.

Lay the fish on top, stuff with the thyme and season generously, inside and out. Dot with the butter, pour over the white wine and 50 ml of the mescal, then wrap up the fish, tightly sealing the edges of the foil.

Bake for 25–35 minutes, or until the fish is just cooked.

Meanwhile, heat a large frying pan over a medium heat and add the oil and onions. Turn down the heat a touch and sweat the onions until they turn soft and translucent, about 10 minutes.

Add the garlic, bay leaves, allspice, marjoram, capers and chillies, and season generously. Cook for a further 10–15 minutes, by which time the onions will taste incredibly sweet. Add the tomatoes, simmer for a further 10 minutes and season to taste.

Once the fish is cooked, pour its juices into the tomato sauce and stir to combine. Serve chunks of the fish with spoonfuls of the sauce.

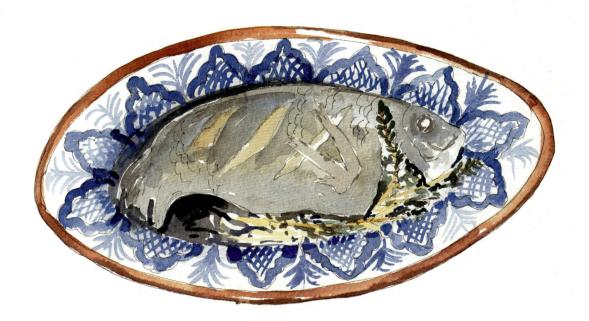

Is it a Common or a Grey Seal?

Common Seal

Also known as Harbour Seals, **Common Seals** (*Phoca vitulina*) are found all over the North Atlantic and North Pacific Oceans, and are extremely common; they are in fact the most widespread of the pinnipeds (mammals that have fin-like flippers for locomotion). About 5 per cent of the total world population of these seals lives around the British Isles. Females can live for as long as 30 years, but males seldom survive beyond 20. The mammals eat a wide variety of fish and crustaceans, tearing their prey to bits and swallowing it without chewing.

Common Seals can be seen lying on rocky shores or sandbanks, where they haul themselves out to rest, sometimes resembling giant bananas. They give birth ashore to a single pup in June or July; the pups are very well developed at birth, and capable of swimming at just a few hours old. A seal's milk is particularly rich and pups double their birth weight in 3–4 weeks. All seals moult their old skin and hair once a year, and during this time they spend a good deal of their time ashore.

The **Atlantic Grey Seal** (*Halichoerus grypus*) is the larger of the two seal species, with a marked difference in size between the sexes – the males can reach 2.5 m in length and weigh 350 kg, whereas the smaller females are 2 m long and weigh 200 kg. Atlantic Greys have a similar diet to that of Common Seals, and can dive to a depth of up to 200 m. Almost half the world population of Atlantic Greys lives around the British Isles.

Atlantic Grey Seal

The seal pups are born at traditional pupping sites known as rookeries. They initially have a white fluffy coat known as lanugo, meaning not waterproof, as a result of which they must spend their first few weeks ashore while suckling. The pups then moult and gain their adult waterproof coats.

Gulls

Most adult gulls are grey, white and black, and fairly easy to identify. Juveniles are, however, extensively marked in shades of brown during the immature stage, which can last 1–4 years depending on the species. Immature birds are often seen with adults, and this is sometimes the only way in which they can be identified even by experienced birdwatchers.

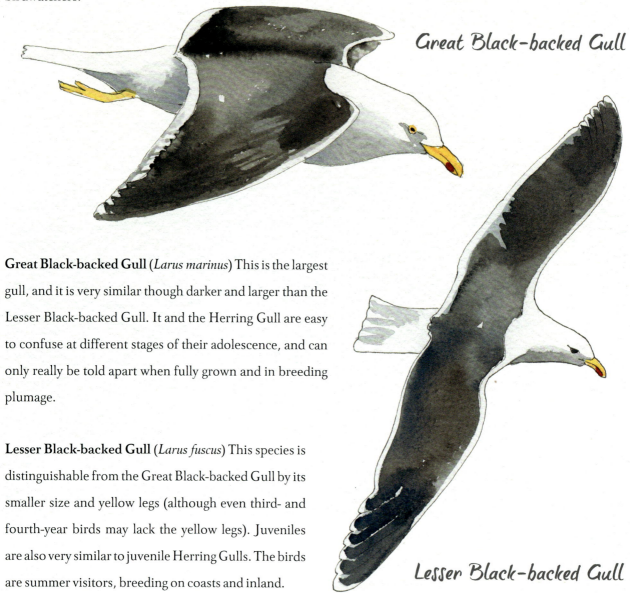

Great Black-backed Gull (*Larus marinus*) This is the largest gull, and it is very similar though darker and larger than the Lesser Black-backed Gull. It and the Herring Gull are easy to confuse at different stages of their adolescence, and can only really be told apart when fully grown and in breeding plumage.

Lesser Black-backed Gull (*Larus fuscus*) This species is distinguishable from the Great Black-backed Gull by its smaller size and yellow legs (although even third- and fourth-year birds may lack the yellow legs). Juveniles are also very similar to juvenile Herring Gulls. The birds are summer visitors, breeding on coasts and inland.

Herring Gull (*Larus argentatus*) These birds vary in size from almost as small as a Common Gull to almost as large as a Great Black-backed Gull. They can be distinguished from Kittiwakes by their pink legs, and from the Great Black-backed by their much paler mantle (or saddle-back). This is a very common gull that can often be seen perched on a favourite telegraph pole or mast.

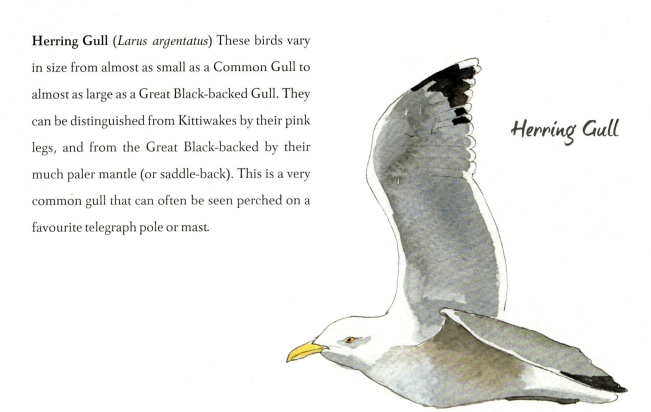

Kittiwake (*Rissa tridactyla*) The Kittiwake is a pretty little gull that loves high sea cliffs and even nests on cliff ledges in breeding colonies, when its cry of *kitt-ee-wayke* can be easily distinguished. Its nest is made of mud, seaweed and grass, and is much sturdier than that of the average gull, perhaps fortunately as this prevents the eggs from rolling off the edges of cliff ledges. After breeding the birds move out into the Atlantic to spend the winter, often accompanying whales and other sea mammals on their travels.

How to make sea-glass jewellery

Sea glass washes up on every beach. It is simply broken glass that has been rolled and ground by the sand until it has no sharp edges, and occurs in a variety of colours. For earrings you need to find a couple of pieces of a similar size – they will not be identical, but that will be part of their charm.

Using a drill with a small, diamond-tipped bit, it is an easy although lengthy process to drill a hole in the glass. All you need is a drill that will take a very small bit, a container with a piece of wood at the bottom on which to place the glass and some water. Fill the container with water so that the glass is covered (this will keep the glass from overheating with the friction of the drill) and drill away. It can take up to five minutes to drill your way through a normal piece of glass. You will be left with a neat hole that will take a ring, and you can then turn the piece into whatever you like.

Here is how to make pendants and earrings without using a drill.

YOU WILL NEED:
- bits of sea glass
- 20-gauge beading wire
- findings
- round- and square-nosed pliers
- wire cutters

Cut off a piece of wire about 30 cm in length.

With the round-nosed pliers make a small hook at one end.

Wrap the wire around the glass as shown in fig. 1.

Create the bail at the top, fig. 2.

Tuck the wire under a cross wire, fig. 3.

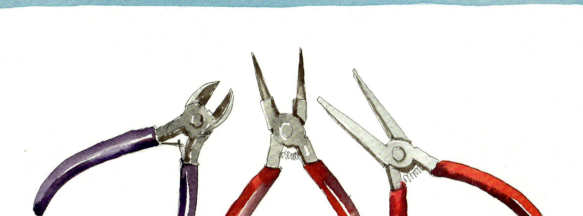

Hold the tip of the wire in the round-nosed pliers and turn. Continue to wind the wire around itself with the square-nosed pliers until it lies tight to the glass.

There are other ways to keep the ends neat: start by creating a bail, fig. 4, and finish as before; or wrap the wire around the glass and create coils with both ends, fig. 5.

Insert the ear hooks.

fig. 1.

fig. 2.

fig. 3.

fig. 4.

fig. 5.

Amazing bills

The **Curlew** (*Numenius arquata*) has a mournful and beautiful musical, bubbling call that once heard is never forgotten. It is the largest of the 'brown' waders, with a 90-cm wingspan and distinctive downcurved bill that it uses for probing in mud for small crustaceans.

Curlew

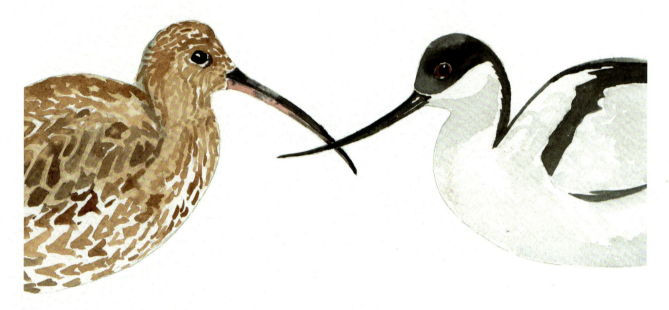

Avocet

Surely the most elegant of wading birds, the **Avocet** (*Recurvirostra avosetta*) favours coastal lagoons and estuaries. Apart from during the breeding season Avocets are gregarious, living in small flocks of up to 30 birds. The upturned bill is used to sweep through the water from side to side when the bird hunts for its quarry, and it can also pick prey delicately from the surface of the water or mud.

Astonishing legs

The **Black-winged Stilt** (*Himantopus himantopus*) is an occasional visitor to the UK and is found in various other parts of Europe. Its legs are 60 per cent of its height, and at 23 cm tall it is able to wade and therefore feed in deeper water than other waders.

The **Grey Heron** *(Ardea cinerea)* has the longest legs of all. This is the largest British bird. They wade into water hunting for fish and, thanks to the length of their legs and their extremely long necks, they can reach into deeper areas than other birds.

Winter

Useful websites

www.marlin.ac.uk
 The Marine Life Information Network is the most comprehensive resource of information about the marine environment of the British Isles. You can download a handy PDF of the Seashore Code here too.

www.metoffice.gov.uk
 The Met Office website provides weather and climate change forecasts for the UK and worldwide, including shipping forecast and gale warnings for seas around the British Isles.

www.nhm.ac.uk
 The website of London's Natural History Museum is an enormous resource covering botany, entomology, mineralogy, palaeontology and zoology. Visit the NHM site's Blue Zone to learn more about marine mammals and invertebrates, fish, amphibians and reptiles.

www.theseashore.org.uk
 This Field Studies Council-linked site helps you interpret and understand the seashore and its organisms.

www.tidetimes.org.uk
 This useful website shows tide predictions for a number of locations around the UK. At the click of a button you can check local details of high tides and low tides up to 7 days ahead.

www.wildlifetrusts.org/living-seas
 The Living Seas area of the Wildlife Trusts website has excellent sections on our marine wildlife and coastal habitats, and offers advice on how you can help the marine environment.

Acknowledgements

Some of the recipes reproduced here are printed with the kind permission of:

The lemon sole, cockles and samphire with garlic parsley dumplings and lemon sauce is by Nathan Outlaw of Nathan Outlaw Restaurants Ltd, www.nathan-outlaw.com

The land and sea spaghetti with anchovy, white wine and chilli is by Ellen Parr of Atlantic Kitchen, atlantickitchen.co.uk

The elderflower and carrageen panna cotta is by Prannie Rhatigan of the Irish Seaweed Kitchen, irishseaweedkitchen.ie

The crabcakes with a tomato, crab and basil dressing by Rick Stein is from *Rick Stein's Taste of the Sea* (1996), BBC Books, and is reprinted with permission of The Random House Group Limited, www.rickstein.com

The spaghetti with clams is by Mitch Tonks from *Fish: The Complete Fish and Seafood Companion* (2009), Pavilion Books, www.mitchtonks.co.uk

The laverbread, cockle and bacon quiche is by Fran Barnikel of the Pembrokeshire Beach Food Company, www.beachfood.co.uk

The red Thai curry mussels by Sarah Raven is from *Sarah Raven's Food for Friends & Family* (2010), Bloomsbury Publishing Plc, www.sarahraven.com

The seared scallops with butter and garlic is by Guy and Juliet Grieves of The Ethical Shellfish Company, the Isle of Mull, ethicalshellfishcompany.co.uk

The pan-fried cod, chips and tartare sauce is by Katriona Macgregor from the 'Speedy Weeknight Suppers' column in the *Telegraph*, www.telegraph.co.uk/journalists/katriona-macgregor

The baked sea-bream à la veracruzana by Thomasina Miers is from *Wahaca: Mexican Food at Home* (2012), Hodder & Stoughton, www.thomasinamiers.com

I would also like to thank:

Barry Boswell, www.britishbirdphotographs.com

British Sea Fishing, www.britishseafishing.co.uk

Caro and Tim, cornishseaweedcompany.co.uk

Cat Gordon, Shark Trust, www.sharktrust.org

Emma Gunn, Eden Project expert forager, nevermindtheburdocks.co.uk

Fiona Halliday, www.discoverwildlife.com

Guy Baker, Marine Biological Association, www.mba.ac.uk

Ian Kimber, www.ukmoths.org.uk

Jessica Winder, Jessica's Nature Blog, natureinfocus.wordpress.com

Mark Taylor, www.warrenphotographic.co.uk

Molly Mahon Blockprinting, www.mollymahon.com

Peter Eales, butterfly-conservation.org

Rosemary Hill, Conchological Society of Great Britain and Ireland, www.conchsoc.org

Sarah Longrigg, UK Shells, www.fredandsarah.plus.com

Sue Daly, for the photos of sea hare, slug and flatworm.

And finally thanks to all the friends and family who have helped me along the way, in particular Helen Riddy.

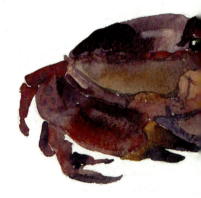

Index

Actinia equina 137
Aeolidia papillosa 169
Alca torda 53
Alexanders 32
　candied stems 33
　preparing fresh stems,
　　flowers and leaves 32
　roasted roots 33
　spicy seeds 33
　tempura flowerheads 33
Alisanders 32
Alliaria petiolata 13
Alpheus macrocheles 70
altocumulus clouds 127
altostratus clouds 126
amber 63
Ammodytes tobianus 102
Ammophila sabulosa 128
Anas acuta 174
Andira inermis 115
Andrena fulva 128
Anemone, Beadlet 137
　Dahlia 137
　Snakelocks 137
Anemonia viridis 137
Angulus tenuis 170
Anthriscus caucalis 38
Anthus petrosus 142
　pratensis 143
Aphroditea aculeata 171
Aplysia punctata 169
April flowers 38
Archidoris pseudoargus 169
Arctica islandica 170
　villica 87
Ardea cinerea 185
Arenaria interpres 157
Arenicola marina 171
Armeria maritima 59
Artemisia absinthium 79
Arthur 140
Aspitriola cuculus 20
Asterias rubens 31
Asterina gibbosa 30
Astropecten irregularis 31
Atriplex laciniata 99

Aurelia aurita 65
Avocet 184

backbones 155
bacterioplankton 158
Badger 138
Baked Sea Bream à la
　Veracruzana 176–177
ballan crosses 111
Bass, European Sea 172
Bauhinia glabra 115
Beach Fish Bake 64
beachcombed wreath,
　making 173
Beaufort Scale 124
Beaufort, Sir Francis 124
Bedstraw, Hedge 86
Bee, Tawny Mining 128
Beech, Sea 25
Beet, Sea 12
Beetle, Beachcomber 128
　Strandline 128
Bellis perennis 79
Beta vulgaris maritima 12
Bindweed, Seashore False
　58
bivalves 170
Bladderwrack 160
bloaters 42
Bloody Henry 30
bones and bone-like objects
　155
Bonxie 69
bracelet, making from
　watercolour paper
　46–47
Brassica oleracea 13
Brill 131
Bristletail, Sea/Shore 128
Broscus cephalotes 128
Bryopsis plumosa 84
Buccinum undatum 49
Bucephala clangula 135
buckling 42
Bufo bufo 67
Bugloss, Viper's 71

Burnet, Greater 86
Butterfly, Brimstone 92
　Clouded Yellow 92
　Common Blue 93
　Glanville Fritillary 93
　Grayling 92
　Green Hairstreak 92
　Lulworth Skipper 92
　Marbled White 93
　Marsh Fritillary 92
　Meadow Brown 93
　Small Heath 93
　Wall Brown 93
By-the-Wind Sailor 61

Cabbage, Sea or Wild 13
Calidris alba 157
　alpina 157
　canuta 157
Calliactis parasitica 137
Calliostoma zizyphinum 49
Callophrys rubi 92
Callophyllis laciniata 24
Calystegia soldanella 58
Campion, Bladder 38
　White 38
Cancer pagurus 81
candelabra, making from
　driftwood 109
Carcinus maenas 80
Cardaria draba 13
Carragen 24
Cat's Ear, Common 79
　dandelion clock 110
Catshark, Small-spotted 11
Centaurea jacea 86
Centaurium erythraea 41
Centranthus ruber 86
Centuary 41
cephalopods 18
Cetorhinus maximus 163
Chaetomorpha linum 85
Chamelea gallina 170
chandelier, making from
　driftwood 116
Chelon labrosus 21

Chervil, Bur 38
Chicory 79
chitons 63
Chondrus crispus 24
Chough 140
Christmas tree, making from
　driftwood 154
Chroicocephalus ridibundus
　148
Chrysanthemum parthenium
　79
Chrysaora hysoscella 65
Cichorium intybus 79
cirrocumulus clouds 126
cirrus clouds 126
Cladophora 85
Cladophora rupestris 85
Clam, Striped Venus 170
Clangula hyemalis 175
clock, making from shells 121
cloud formations 126–127
Clupea harengus 42
coat-of-mail shells 63
Codium tomentosum 84
Coelopa frigida 128
Coenonympha pamphilius 93
Colias croceus 92
Columbus, Christopher 115
Coral Weed, Common 25
Corallina officinalis 25
Cormorant 164, 165
Cornwall 140
Coryphella browni 169
Crab, Common or Edible 81
　Shore 80
　Spider 81
　Velvet Swimming 81
Crabcakes with a Tomato,
　Crab and Basil Dressing
　56–57
crabs 80–81
Crambe maritima 12
Crangon crangon 70
Crassostrea angulata 120
　gigas 120
Crepis biennis 110

· 189 ·

Cress, Hoary 13
crosh ballan 111
Crossaster papposus 31
cruciferae 12–13
Cucullia absinthii 87
cumulonimbus clouds 127
cumulus clouds 127
Curlew 184
cuttlefish 18
 Common 19
 cuttlefish bone 155
Cyanea capillata 65
 lamarckii 65
Cyprine, Icelandic 170

Dab, Common 130
Daisy, Common 79
 Ox-eye 38, 79
Dandelion 79, 110
 dandelion clocks 110
Dead-nettle, White 38
Deilephila porcellus 87
Delesseria sanguinea 25
Delphinus delphis 114
Dicentrarchus labrax 172
Dilsea carnosa 24
Diodora gracea 55
Diver, Black-throated 62
 Great Northern 62
 Red-throated 62
Dolphin, Short-beaked
 Common 114
dominoes, making from
 slate 162
Dory, John 54
Dover, White Cliffs of 158
driftwood candelabra,
 making 109
 chandelier, making 116
 Christmas tree, making
 154
 seahorse, making 100
 table lamp, making 39
Duck, Long-tailed 174, 175
Dulse 25
 Pepper 25
Dunlin 156, 157
Eagle, White-tailed 108
earrings, making from
 watercolour paper
 46–47

Echinocardium cordatum
 76, 77
Echinus esculentus 76, 77
Echium vulgare 71
Eden Project 32
Eider, Common 14, 15
Elderflower and Carragheen
 Panna Cotta 40
Elysia viridis 169
Emma's Life-enhancing Salt
 and Pepper Squid with
 Guacamole Dip 34–35
Ensis ensis 170
Entelurus aequoreus 113
Epidalea calamita 67
Epitonium clathrus 49
Erodium cicutarium 38
Eryngium maritimum 98
estuary flowers 99
Eumarginula fissura 55
Eunicella verrucosa 117
Euphorbia paralias 99
Euphydryas aurinia 92
Euproctis similis 87
exoskeletons 155

Fan Weed 24
feathers 152–153
Feverfew 79
fish, filleting 129
fish jewellery, making from
 watercolour paper
 46–47
fish kite, making 125
FitzRoy, Robert 122
flatfish 106–107, 130–131
Flounder, European 131
Flustra foliacea 115
Fly, Kelp 128
Fratercula arctica 90
Fucus serratus 160
 spiralis 160
 vesiculosus 160
Fulmar 52, 108
Fulmarus glacialis 52
Furbellows 133

Galium mollugo 86
Gannet 69, 74–75
Gari fervensis 170
Garlic Mustard 13
gastropods 168–169
Gavia arctica 62
 immer 62
 stellata 62
Genista tinctoria 86

Geranium sanguineum 79
Geranium, Blood-red 79
Gibbula magus 49
Glasswort, Common 99
Glaucium flavum 71
Goat's Beard 79
 dandelion clock 110
Godwit, Bar-tailed 156, 157
Goldeneye 135
Gonepteryx rhamni 92
Greenshank 8, 9
Greenweed, Dyer's 86
Guillemot, Common 36
 eggs 37
Gull, Black-headed 148
 eggs 48
Gull, Common 181
 eggs 48
Gull, Great Black-backed
 180, 181
 eggs 48
Gull, Herring 180, 181
 eggs 48
Gull, Lesser Black-backed
 180
 eggs 48
Gull, Little 148
Gunn, Emma *Never Mind
 the Burdocks* 32
Gurnard, Red 20
Gutweed 84, 85

Haddock Gravadlax 136
Haematopus ostralegus 26
Haliaeetus albicilla 108
Halichoerus grypus 179
Halimione portulacoides 99
Haliotis lamellosa 55
 tuberculata 55
Hamburger Bean 115
Hawk-moth, Bedstraw 87
 Small Elephant 87
 Spurge 87
Hawk's-beard, Rough 110
Hawkder, R. S. 'The Wreck'
 140
Hawkweed, Mouse-eared
 41, 79
 dandelion clock 110
Hediste diversicolor 171
Helcion pellucidum 55
Hen Pen 84
Henny's Seaside Monkfish
 Wraps 94–95

Henricia oculata 30
Hermit Crab, Common 81
Heron, Grey 185
Herring, Atlantic 42–43
Himantopus himantopus 185
Hinia reticulata 49
Hipparchia semele 92
Hippocampus hippocampus
 113
Hippolyte varians 70
hobby seahorse, making
 144–145
Homarus gammarus 118
Hornwrack 115
Horse-eye Bean 115
Hydrocoleus minutus 148
Hyles euphorbiae 87
 gallii 87
Hyperoplus lanceolatus 102
Hypochaeris radicata 79, 110

insects 128
Irish Moss 24

Jack in the Hedge 13
Janthina janthina 49
Jasione montana 41
Jellyfish 61
 Blue 65
 Bluebottle 61
 Compass 65
 Lion's Mane 65
 Moon 65
jewellery, making from sea-
 glass 182–183
July flowers 86
 flowerheads 79
June flowers 71

Kale, Sea 12
Kelp 133
 Grass 84, 85
Kipper Pâté 151
kippers 42
Kiss-Me-Quick 86
Kittiwake 181
 eggs 48
Knapweed, Brown 86
Knot 157

Labrus bergylta 111
Lacerta agilis 66
Laminaria digitata 133
Lamium album 38

Land and Sea Spaghetti with Anchovy, White Wine and Chilli 28
Langoustine 150
Lapsana communis 79
Larus argentatus 181
　fuscus 180
　marinus 180
Lasiocampa trifolii 87
Lasiommata megera 93
Laverbread, Cockle and Bacon Quiche 82–83
Lemon Sole, Cockles and Samphire with Garlic Dumplings and Lemon Sauce 16–17
Leucanthemum vulgare 38, 79
Leucoma salicis 87
Limacia clavigera 169
Limanda limanda 130
Limonium vulgare 98
Limosa lapponica 157
Limpet, Black-footed 55
　Blue-rayed 55
　Common 55
　Common Tortoiseshell 55
　Keyhole 55
　Slipper 55
　Slit 55
Linaria vulgaris 86
Littorina littorea 49
　nigrolineata 49
Lizard, Sand 66
Lobster, Common 118–119, 150
　Norway 150
Loligo vulgaris 19
loons 62
Lotus corniculatus 71
Lugworm 171
Luidia ciliaris 31
Lutra lutra 138
Lutraria lutraria 170

Mackerel, Atlantic 96–97
　Horse 21
Macoma balthica 170
magnetic fish game, making 88
Maja squinado 81
Mallow, Common 79
Malva sylvestris 79

Maniola jurtina 93
Marten, Pine 138
Marthasterias glacialis 30
May flowers 41
Mayweed, Sea 79
Melanargia galathea 93
Melanitta nigra 135
Melitaea cinxia 93
Mergus albellus 134
Merlangius merlangus 20
mermaid's purses 10, 11
Microstomus kitt 107
Miers, Thomasina *Wahaca: Mexican Food at Home* 176
Mimachlamys varia 101
　varia nivea 101
molluscs 18–19
Molly's Mackerel Bake 132
moon 23
Morus bassana 74
Moth, Buff Ermine 87
　Cream-spot Tiger 87
　Great Eggar 87
　Lobster 103
　Six-spot Burnet 87
　White Satin 87
　Wormwood 87
　Yellow-tail 87
Mullet, Grey 21
Murre 36
Mya truncata 170
Myoxocephalus scorpius 89

Natrix natrix 67
nautiluses 18
Navelwort 59
Nebria complanata 128
Necora puber 81
Nemalion helminthoides 24
Nephrops norvegicus 150
Nerophis lumbriciformis 113
Nickernut 115
Nightshade, Woody 71
nimbostratus clouds 127
Nipplewort 79
Noodle, Sea 24
Nucella lapillus 49
Numenius arquata 184
Nursehound 11

Oak, Sea 25
Oarweed 133
Octopus vulgaris 18

Octopus, Common 18
Ononis repens 103
Orache, Frosted 99
Ormer, Common 55
　Green 55
Ormosia spp. 115
Osmundea pinnatifida 25
Ostrea edulis 120
Otter Shell, Common 170
Otter, European 138–139
oyster-shell fish, making 68
Oyster, European Flat 120
　Pacific 120
　Portuguese 120
Oystercatcher 26–27
oysters, opening 120

Pagellus bogaraveo 21
Pagurus bernhardus 81
Palaemon serratus 70
Palliotum tigerinum 101
Palmaria palmata 25
Pan-fried Cod, Chips and Tartare Sauce 166–167
Paracentrotus lividus 76, 77
Parsley, Horse 32
Patella depressa 55
　vulgata 55
pebble tablecloth weights, making 60
Pecten maximus 101
pelmanism, cockleshell 78
Pennywort 59
Pepperwort, Hoary 13
Periwinkle, Black-lined 49
　Common 49
Phalacrocorax aristotelis 164
　carbo 164
Philoceras fasciatus 70
Phoca vitulina 178
Phocoena phocoena 114
Pholas dactylus 149, 170
Phycodrys rubens 25
Physalia physalis 61
phytoplankton 158
Piddock, Common 149, 170
Pilchard 21
Pilosella officinarum 41, 79, 110
Pink, Sea 59
Pintail 174
Pipefish, Greater 113
　Snake 113
　Worm 113

Pipit, Meadow 142, 143
　Rock 142
Plaice, European 131
plankton 158
Platichthys flesus 131
Pleuronectes platessa 131
Pollachius pollachius 21
　virens 20
Pollack 21
Polyommatus icarus 93
Poppy, Yellow Horned 71
Porpoise, Harbour 114
Portuguese Man-of-war 61
Pout 20
Prasiola stipitata 85
Prawn, Chameleon 70
　Common 70
　Dublin Bay 150
　Snapping 70
Psammechinus miliaris 76, 77
Pterobius maritimus 128
Puffin 69, 90–91
Pyrrhocorax pyrrhocorax 140

Ragworm, Estuary 171
Ragwort 79
Raja clavata 10
　montagui 10, 11
　undulata 10, 11
Raven, Sarah *Food for Friends & Family* 112
Ray, Spotted 10, 11
　Thornback 10
　Undulate 10, 11
Razor Shell, Common 170
Razorbill 53
Recurvirostra avosetta 184
red herrings 43
Red Rags 24
Red Thai Curry Mussels 112
Redshank 8
Restharrow, Common 103
Rhincodon typus 163
Rhodiola rosea 59
Rissa tridactyla 181
Rissoides desmaresti 70
rollmops 42
Roseroot 59

Saccorhiza polyschides 133
Sailor, Purple 61
Saithe 20
Salicornia europaea 99
salt, sea 29

Sandeel, Greater 102
 Lesser 102
Sand Gaper 170
Sanderling 156, 157
Sanguisorba officinalis 86
Sardina pilchardus 21
Scallop, Great 101
 Tiger 101
 Variegated 101
 White Variegated 101
Scampi 150
Scarlet Lady 168, 169
Scilla verna 38
Scomber scombrus 96
Scophthalmus maximus 131
 rhombus 131
Scoter, Common 135
Scyliorhinus canicula 11
 stellaris 11
sea anemones 137
sea areas 122–123
sea beans 115
Sea Bindweed 58
Sea Buckthorn Jelly 141
Sea Fan, Pink 117
Sea Hare 168, 169
Sea Heart 115
Sea Holly 98
Sea Lavender 98
Sea Lemon 168, 169
Sea Lettuce 85
Sea Mouse 171
Sea Pie 26
Sea Pink 59
Sea Potato 76, 77
Sea Purslane 99
Sea Scorpion 89
 Long-spined 89
Sea Slug, Grey 168, 169
 Orange-clubbed 168, 169
 Solar-powered 169
Sea Spurge 99
sea stars 30–31
Sea Swallow 44
sea urchins 76–77
Sea-blite, Annual 99
Sea-bream, Black 20
Sea-bream, Black-spot 21
sea-glass jewellery, making 182–183
Sea-spurrey, Lesser 99
Sead 21
seahorse, making from driftwood 100

Seahorse, Short-snouted 113
Seal, Atlantic Grey 178, 179
 Common/Harbour 178, 179
Seared Scallops with Butter and Garlic 159
seaweed trees 117
seaweeds, green 84–85
 red 24–25
Sedum acre 41
 anglicum 41
 reflexum 59
Senecio jacobaea 79
Sepia officinalis 19
Shag 164, 165
Shark Trust 10
Shark, Basking 163
 Whale 163
Sheep's-bit 41
Shelduck 14
shipping forecasts 122–123
Shrimp, Brown 70
 Mantis 70
Silene latifolia 38
 vulgaris 38
siphonophores 61
skates 10, 11
skeletons 155
Skua, Arctic 69
 Great 69
skulls 155
slate dominoes, making 162
Smew 134
Smyrnium olusatrum 32
Snail, Violet 49
Snake, Grass 67
Solanum dulcamara 71
Sole, Dover/Common/Black 106, 107, 130
 Lemon 107, 130
Solea solea 106
Somateria mollissima 15
Sonchus arvensis 110
soused herring 42
Spaghetti with Clams 72–73
Speedwell, Germander 38
Spergularia marina 99
Spilarctia luteum 87
Spondyliosoma cantharus 20
spoons, making from shells 22
squid 18
Squid, European or Common 19

Squill, Spring 38
St Peter's Fish 54
Stachys palustris 86
Star, Common Sun 31
 Cushion 30
 Sand 31
starfish 30–31
 Common 31
 Seven-armed 31
 Spiny 30
Stauropus fagi 103
Stercorarius parasiticus 69
 skua 69
Sterna hirundo 44
 paradisaea 44
Stilt, Black-winged 185
Stoat 138
Stonecrop, English 41
 Reflexed 59
Stork's-Bill, Common 38
stratocumulus clouds 127
stratus clouds 126
Suaeda maritima 99
Sunset Shell, Faroe 170
Syngnathus acus 113
Syrrhaptes paradoxus 96

table lamp, making from driftwood 39
tablecloth weights, making from pebbles 60
Tadorna tadorna 15
Taraxacum officinale 79, 110
Tauralus bubalis 89
Tectura testudinalis 55
teeth 155
Tellin, Baltic 170
 Thin 170
Tern, Arctic 44
 Common 44–45
Thistle, Common Sow 110
Thrift 59
Thyme, Wild 41
Thymelicus acteon 92
Thymus serpyllum 41
tides 23
Toad, Common 67
 Natterjack 67
Toadflax, Common 86
Top Shell, Painted 49
 Turban 49
Trachurus trachurus 21
Tragopogon pratensis 79, 110
Tree, Cabbage-bark 115

Trefoil, Bird's-foot 71
Tringa nebularia 9
 totanus 9
Tripleurospermum maritimum 79
Trisopterus luscus 20
Turbot 131
Turnstone 157

Ulva intestinalis 84, 85
 lactuca 85
Umbilicus rupestris 59
Urchin, Edible Sea 76, 77
 Green Sea 76, 77
 Purple Heart 76, 77
Uria aalge 36
Urticina felina 137

Valerian, Red 86
Velella velella 61
Velvet Horn 84
Veronica chamaedrys 38
Vetch, Tufted 86
Vicia cracca 86
Vine, Monkey Ladder 115

Wallpepper 41
Wasp, Red-banded Sand 128
Weasel 138
Wentletrap, Common 49
Whelk, Common 49
 Dog 49
 Netted Dog 49
Whiting 20
Wildlife and Countryside Act (1981) 163
worms 171
Wormwood 79
Woundwort, Marsh 86
Wrack, Spiral 160
 Toothed 160
wracks 160–161
Wrasse, Ballan 111
wreath, making from beachcombings 173

Zeus faber 54
zooplankton 158
Zygaena filipendulae 87